MAKE MANGA!

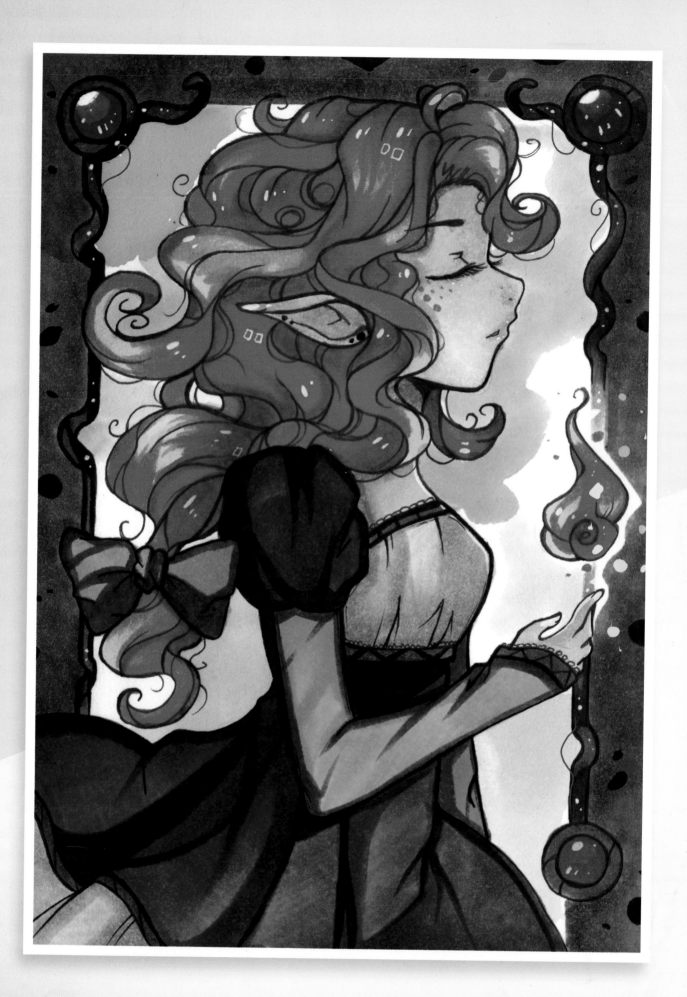

MAKE MANGA!

Create Characters & Scenes

• KAROLINA "LARIENNE" HEIKURA •

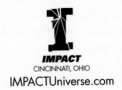

IMPACT
CINCINNATI, OHIO
IMPACTUniverse.com

TABLE OF
CONTENTS

WHAT YOU NEED

Surface
drawing paper
watercolor paper

Sketching Tools
eraser
mechanical pencil
multiliner pen

Coloring Tools
markers
watercolor brushes
watercolor paints
white gel pen

Optional
anatomical puppet
silver marker or pen

Introduction

What does it mean to be an artist? One of the key elements of being an artist is the ability to bring your own vision to life. This ability is strongly connected to creativity and all the possibilities of creating a work of art. I believe that each of us is unique and bringing that uniqueness of ourselves into our art is what makes it special. While knowledge of anatomy or fine painting skills may give you a significant advantage, the ability to exercise your own creativity is no less important.

This book will take you through the basics of sketching faces and figures, as well as designing clothing, accessories and backgrounds, so you can create your own characters and place them in fantastic scenes and settings. When it comes to the coloring process, we will focus on traditional media such as watercolors and markers and explore what these tools can do when you combine them.

Regardless of the type of art you wish to create, the goal of this book is to stir your imagination, to give you ideas for executing your illustrations, to help you discover your own means of expression and to inspire you on your artistic journey. So don't wait any longer—the art world is waiting to see your personality expressed!

TOOLS & SUPPLIES

There are many art tools that can help you create stunning pieces. Although tools do not make the artist, they can definitely help make the artistic process smoother and more pleasant. The following supplies were used to create the pieces featured in this book. Experiment to find what works best for you.

Paper

Choosing the correct paper is important to achieving a successful final result. If you plan to use watercolors, then your sketch should be done on watercolor paper. Watercolor paper also works well with markers. Just be aware that using markers on watercolor paper over a long period of time may damage the nibs. (Though these can be replaced.) If you don't plan to add color to your sketch, any type of paper will work. Working in a sketchbook will make it easier to keep your drafts organized.

Pencils

Pencils are available in a range of lead types, from soft to hard. I normally use a Pentel mechanical pencil with 0.3mm HB lead, but any brand is fine. The main advantage of mechanical pencils is that the lead can be refilled or switched out for a different size or type. Choose the type of lead based on what you want to sketch. Small details are best drawn with very soft, thin leads like H or HB. Shading bigger areas is best done with a harder lead, such as B, 2B or even 6B.

Markers

Markers are one of the most popular traditional coloring tools. They work well with both watercolors and colored pencils, and they come in a wide range of colors. In my experience, brush-nib markers are the most comfortable to work with because they give you better control over the amount of ink being applied. Some brands, like Copic markers, offer markers with refillable ink cartridges. These may be worth purchasing for the most used colors in your collection.

Watercolors

Watercolors have been gaining popularity as a coloring medium due to the array of fresh and vibrant colors available. Both liquid and standard watercolors are exceptionally economical because they can be used for a long time, so investing in quality watercolors will pay off in the long run.

Brushes

There are various sizes and types of brushes available. I prefer to use only a few watercolor brushes: size no. 2 for small details and sizes no. 3 or no. 4 for everything else.

Multiliners

Once you have finished your sketch, a multiliner pen is a great tool for outlining. There are many different brands and levels of thickness to choose from. As with pencils, thinner multiliner pens are better for small details. Many artists choose not to use black multiliners, but rather color the lineart with variations of brown, red, blue or pink for a more natural look once the sketch has been colored in.

Supplies for Adding Finishing Touches

There is almost no limit to what can be used when you are ready to add finishing touches to your work.

◇ Pastels work great when mixed with watercolors and usually work well for covering large areas.

◇ Pens can be used to add details like a character's eyebrows or to strengthen certain lines to provide a variety of line weights.

◇ Gold or silver markers can be used to decorate frames, ornaments, jewelery or clothes. The ink is not transparent, so they can cover areas that have already been colored with other media.

◇ Fluorescent markers are perfect for adding a special glow to an area of your illustration or for highlighting specific elements within the composition.

◇ Colored pencils are great complementary tools for watercolors and markers. While I don't use them in this book, you can use them to add details and put emphasis on certain elements of the illustration. They are often used to add more shading to the skin.

◇ White gel pens are the indispensible tool of every traditional manga artist. They are most often used to add glow and highlights to an illustration. Alternatively, white opaque paint can be used instead.

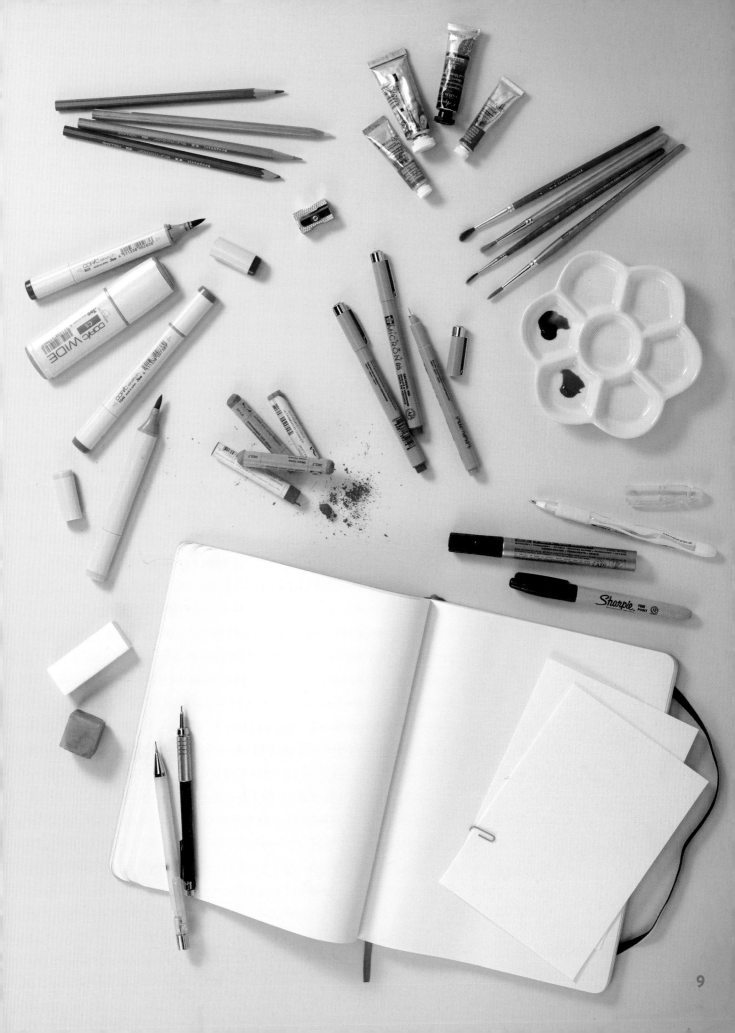

The Basics

Possessing knowledge of basic human anatomy can be incredibly helpful, especially if you are just starting out on your artistic journey. For this reason, we will take time to study fundamentals of anatomy and practice applying them while drawing manga and anime characters.

BODY BASICS

Human bodies can be quite simplified in the manga style, but they still must follow the rules of anatomy. The more anatomical rules you apply, the better the figure will look. Before you can begin playing around with body proportions, you must learn the basics. As manga style continues to evolve into more and more detailed forms, you will be able to bend and adjust as needed, so long as you have a solid foundation in the basics of body anatomy.

When drawing the human figure, we measure the body height in heads. A male figure of average height should be about seven heads tall. The average female figure height would be about six heads tall. A child might be only three or four heads tall. Simply add and remove "heads" until you get to the height you desire for your character.

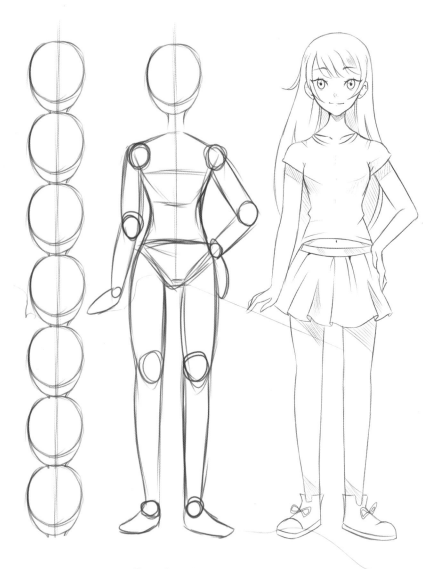

• • • Drawing the Female Figure • • •
A woman's shoulders are narrower than those of a man.
Women also have more delicate, thinner necks than men do.
Use small circles to represent the major joints.

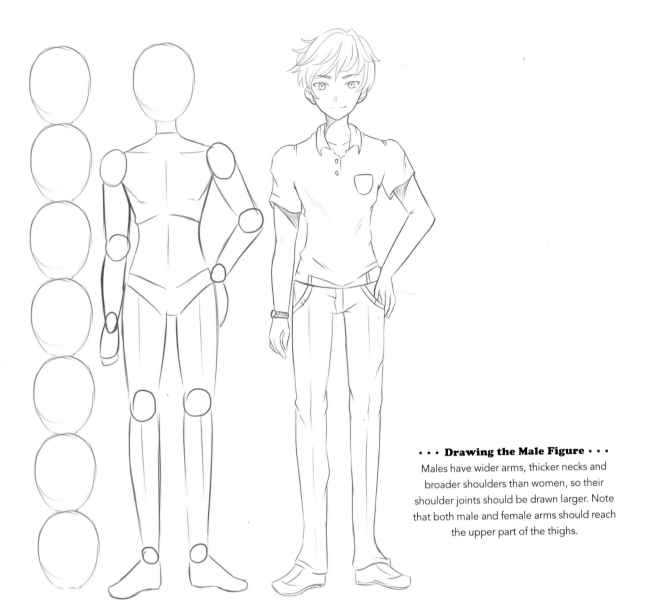

• • • Drawing the Male Figure • • •

Males have wider arms, thicker necks and broader shoulders than women, so their shoulder joints should be drawn larger. Note that both male and female arms should reach the upper part of the thighs.

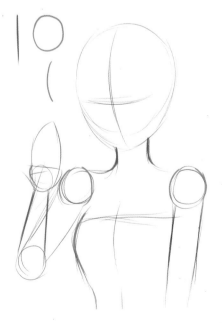

• • • Using an Anatomical Puppet • • •

One of the easiest ways to draw a figure is to use an anatomical puppet. Practice drawing a random character using an anatomical puppet as a basis. Study the puppet and you will notice that it consists mostly of circles (green), curved lines (red) and straight lines (blue).

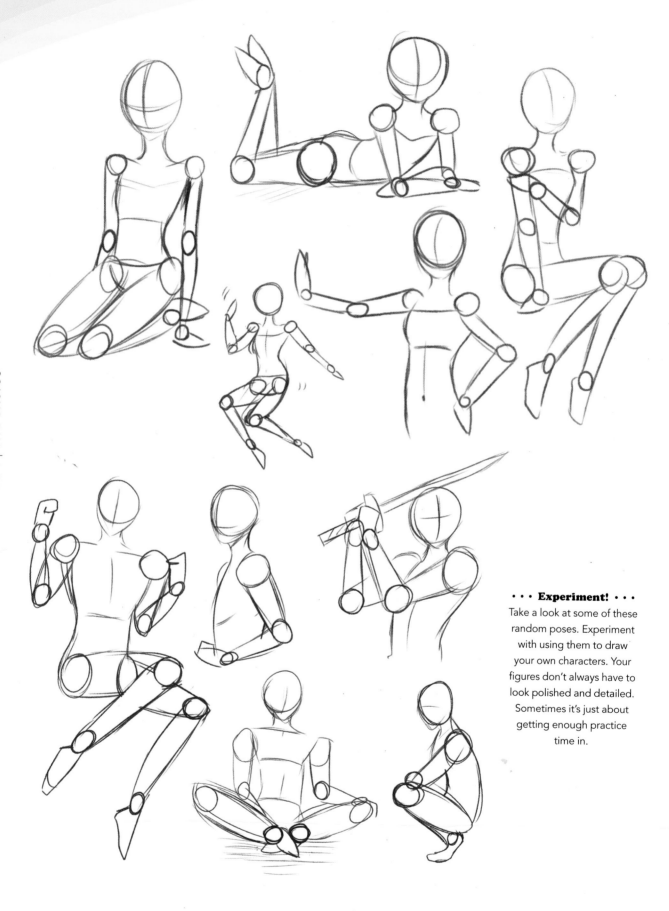

• • • Experiment! • • •

Take a look at some of these random poses. Experiment with using them to draw your own characters. Your figures don't always have to look polished and detailed. Sometimes it's just about getting enough practice time in.

SKETCHING

Doodling and sketching to create various concepts is an important step in coming up with ideas for illustrations. Sketching should be the moment of absolute freedom for your artistic creativity, when your ideas are released and transferred to a sheet of paper.

During the sketching phase, don't be distracted, limited by space or pressured to make everything look neat and clean. Here are a couple of tricks that will make the sketching process much more fun for you.

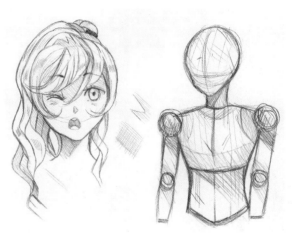

• • • Crosshatching • • •

One of the most common shading techniques is crosshatching, which involves covering an area with intersecting sets of parallel lines. They can be messy. A variation of that style has been introduced in this illustration. Use crosshatching to add shadows and texture to your characters.

• • • Vary Line Thickness • • •

Try to vary the thickness of your lines. Use stronger and weaker lines to make your sketches more dynamic.

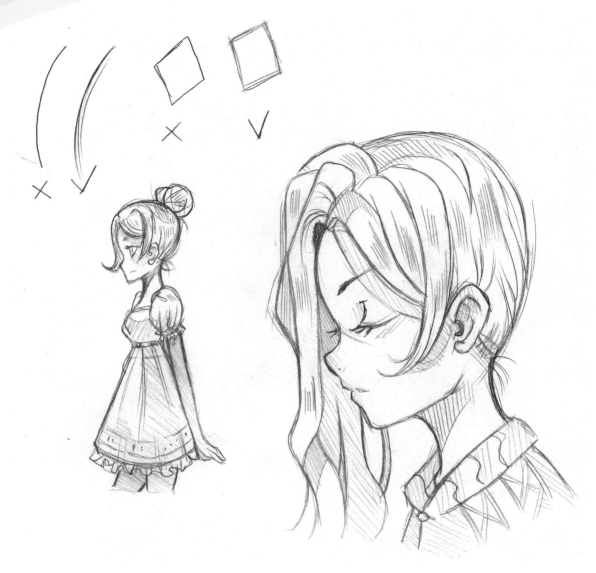

• • • Vary the Number of Lines • • •

Instead of creating one line, draw a variety of lines and strengthen the one line among them you like the most. It will give your sketches more life.

• • • Use Yourself as Reference • • •

Use your own body as your guideline. It is very common among artists to use their own hands and feet as references.

DRAW FOUNDATIONAL FIGURES

Let's take a look at how to approach sketching the upper body of a basic figure to serve as the foundation for a character.

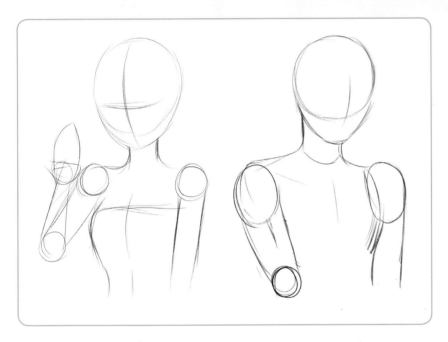

1 Start by drawing an oval with a cross in the middle for the head. Add smaller circles in the joint areas, such as the shoulders, elbows and wrists. Connect everything with straight or curved lines. Use straight lines to form the neck and connect the arm joints. Use curved lines in the face and shoulder areas.

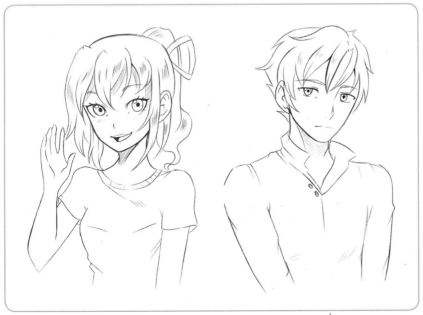

2 Now use the basic figure as a foundation for a character. It makes it much easier to add all the details in the correct places.

◊ DEMONSTRATION ◊

DRAW EYES

The eyes are the windows to the soul when it comes to drawing people, because the eyes are one of the first things to draw the viewer's attention.
The following steps will show you how to draw an eye that leaves a lot of room open for experimentation.

<table>
<tbody>
<tr><td>**MATERIALS**</td></tr>
</tbody>
</table>

Surface
drawing paper

Sketching Tools
eraser
mechanical pencil
multiliner pen

Coloring Tools
colored pencils or markers
white gel pen

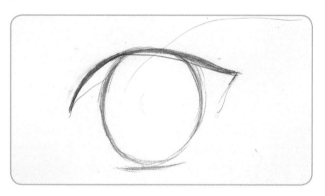

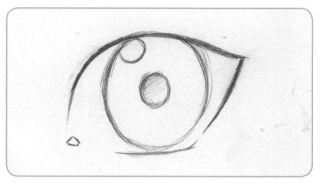

1 Draw a curvy line and a small straight line below it. Then draw a circle to fill the space in between the lines. This will form the iris of the eye.

2 Draw three smaller circles—one in the middle of the iris to form the pupil, one in the upper left area of the iris and one at the left end of the bottom curved line. Connect the right sides of the bottom and top curved lines with a straight line, creating a sharp corner.

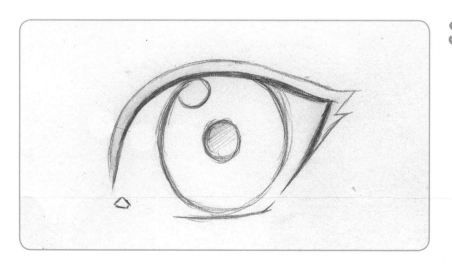

3 Draw another line above the top curved line to form the eyelid.

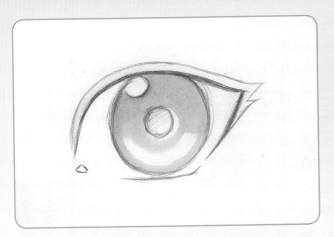

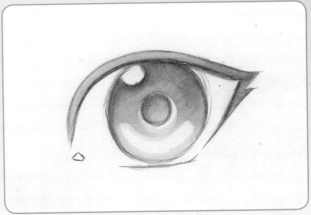

4 Color in the iris with a colored pencil. Leave some white space as shown. I used blue, but you can use any color you want.

5 Color in the eyelid using the color from Step 4. Then use a darker hue on the upper part of the iris. Quickly blend into the area with the lighter color. Do the same thing in the right corner of the eye.

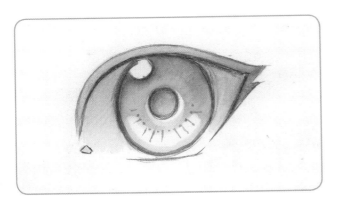

6 Add straight lines in the middle of the eye. Use a gray marker to color the sclera (the white space surrounding the iris). Use a pink hue to color the small dot in the left corner of the eye.

7 Use a multiliner to darken the lines and make them stronger. Add shiny effects with a white gel pen. Feel free to add some other decoration, such as a star, a heart or a diamond shape. Add blush lines with pink and draw an eyebrow above the eye.

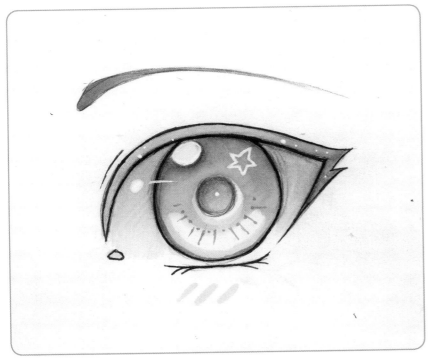

DRAW A NOSE

Follow the steps to draw a simple manga-style nose.

MATERIALS

Surface
drawing paper

Sketching Tools
eraser
mechanical pencil

1 Draw a vertical line.

2 Add a curved line to the left side of the vertical line. It should now look like an archer's bow.

3 Add a small dot to the bottom right side of the nose.

4 Add some shading between the vertical line and the curved line to complete the nose.

◇ DEMONSTRATION ◇

DRAW LIPS

Drawing lips might seem difficult, but it doesn't have to be.
Follow the steps to create manga lips.

MATERIALS	**Surface** drawing paper **Sketching Tools** eraser mechanical pencil

1 Draw a wavy line with two "hills." Add small dots on each end of the line.

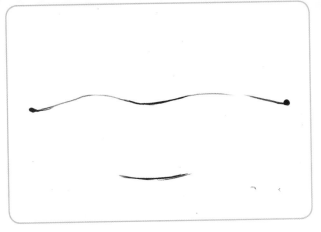

2 Add a small, slightly curved line below the wavy line to create the lower lip.

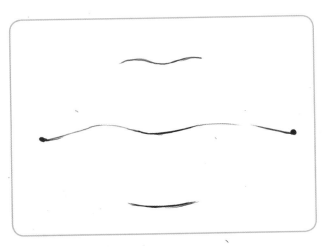

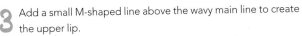

3 Add a small M-shaped line above the wavy main line to create the upper lip.

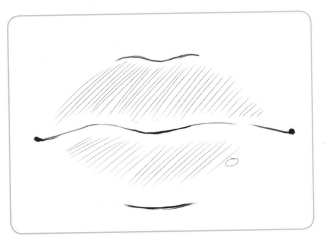

4 Add shading to both the upper and lower lips to finish.

DRAW EARS

Follow the steps below to draw anime and manga-style ears.

MATERIALS

Surface
drawing paper

Sketching Tools
eraser

mechanical pencil

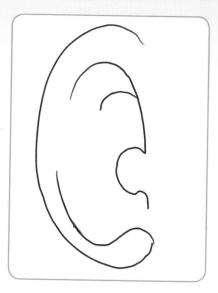

1 Draw a curved line, somewhat like a C-shape.

2 Develop the bottom of the ear by extending the line around and back upwards, following the shape of the original curve.

3 Add two curved lines going the opposite direction near the upper part of the ear. Draw a rounded line to connect them.

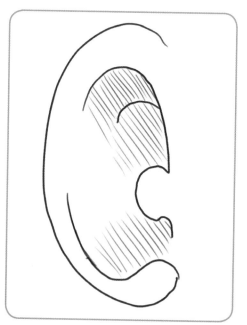

4 Add shading into the upper and lower parts of the ear.

DRAW HAIR

Drawing hair can be lots of fun. There are many styles and variations you can play around with. Follow the steps below for a place to start.

MATERIALS

Surface
drawing paper

Sketching Tools
eraser
mechanical pencil

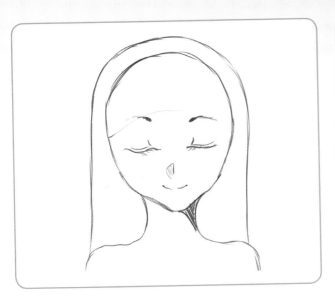

1 Draw a curvy line that goes around the head. Make sure there is some distance between the top of the head and the line.

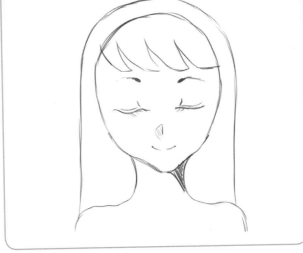

2 Draw lines above the eyebrows to create bangs. You can start from either side of the head.

3 Add some chunks of hair that fall onto the cheeks.

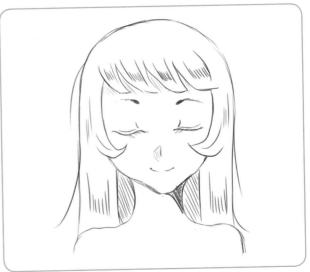

4 Add shading and individual strands of hair to the sides for a more natural look.

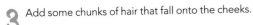

DRAW A FACE, FRONT VIEW

Drawing faces can be fun. While drawing the head from the forward-facing perspective, focus on keeping it symmetrical. Be sure to position all of the facial elements an appropriate distance from one another. Following the guidelines presented in the steps below will make the process easier.

MATERIALS

Surface
drawing paper

Sketching Tools
eraser
mechanical pencil

Optional
white gel pen

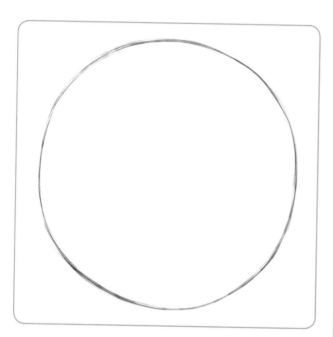

1 Start by drawing a circle. Don't worry about making it perfectly round. It will serve as a guideline and will be erased later.

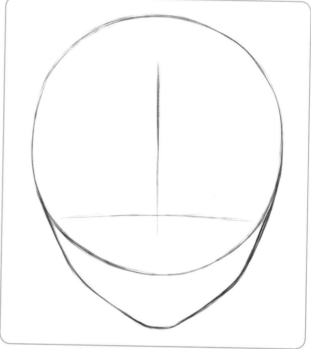

2 Add two intersecting lines, one vertical and one horizontal, close to the bottom of the circle. Draw in the jawline. It can be pointy or square, whatever your preference. Just make sure that the point of the chin is aligned directly below the point where the intersecting lines meet.

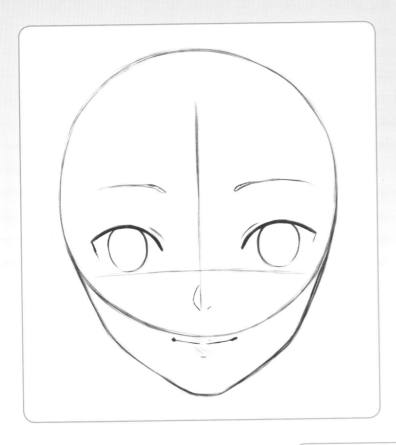

3 Form the eyes by drawing two circles above the horizontal line. Be sure to place the eyes so that they are an equal distance from the vertical line. Add eyelids and eyebrows above the eyes. Draw in the nose towards the bottom of the vertical line. Add lips slightly below the circle guideline.

4 Add hair around the face using the circle as your guideline. Keep some distance between the line of the hair and the circle. Add the neck below the chin. Add detail to the hair.

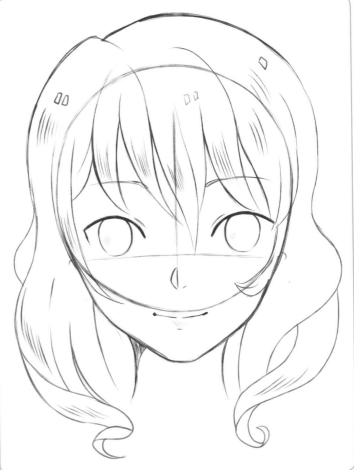

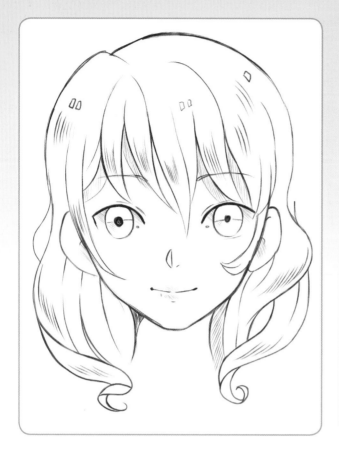

5 Erase the guidelines. Add dots in the middle of the eyes. Begin shading the forehead, neck and lips. If they are visible, add ears on both sides of the head. They should begin around the same height as the eyes.

6 Shade above the eyes to add some more life to them. Use a white gel pen to add white dots for highlights. Add more shading to the ears, hair and face. At this point, you can also add some accessories if you wish, such as a bow or earrings.

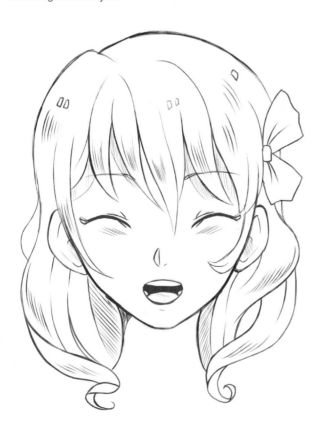

· · · Experiment With Expressions · · ·
Play around with other facial expressions. For example, if you close the eyes and open the mouth, you can achieve a cheerful expression.

DRAW A FACE, PROFILE VIEW

Drawing profiles might be a bit trickier than drawing a front view, but there are a few things you can do to make it much easier.

MATERIALS

Surface
drawing paper

Sketching Tools
eraser
mechanical pencil

1 Draw a circle.

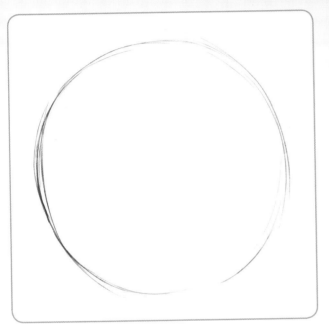

2 Draw a vertical line in the middle of the circle, then draw four horizontal lines that are at the same distance from one another. These will be your guidelines.

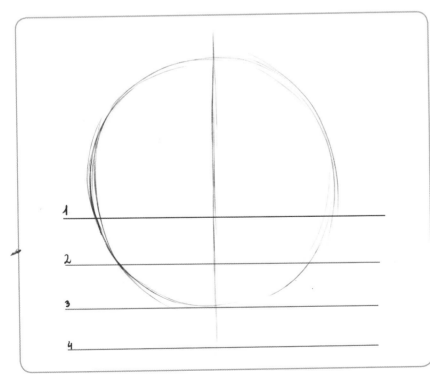

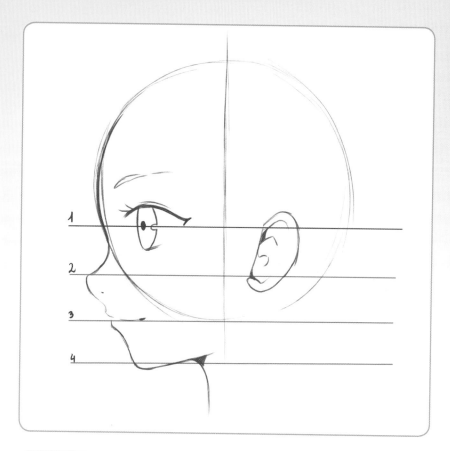

3 Begin the eye by drawing an ellipse, then add lines above and below it. The pupil should be on the first guideline. Add an eyebrow above the eye. Draw the nose and the jaw between the second and fourth lines. Place the lips on the third line. Add an ear between the first and second lines.

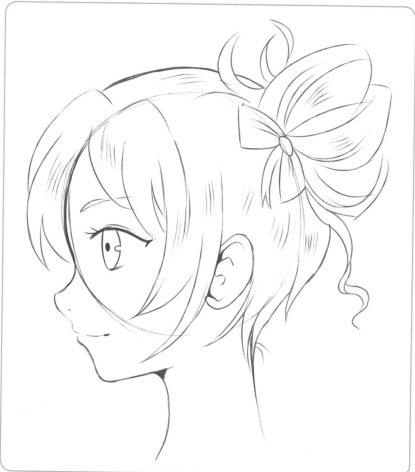

4 Add the back of the neck and the hair by following the circle guideline. The hair adds some size to the head, so remember to keep distance between the line of hair and the circle. I've added some detail to the hair and a hair bow, but you can wait until Step 6 for that.

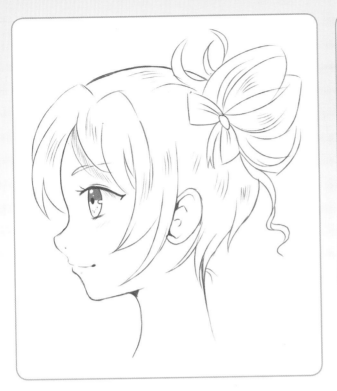

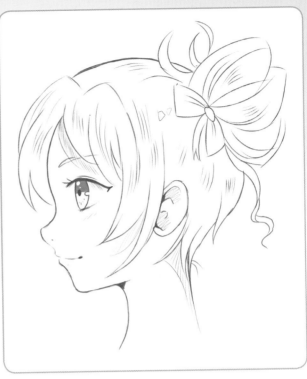

5 Erase your guidelines. Fill in the upper half of the eye to add detail. Add some shading under the hair on the forehead.

6 Add more shading to the ear, neck and hair using straight lines. You can add any accessories you want, such as earrings or hair clips.

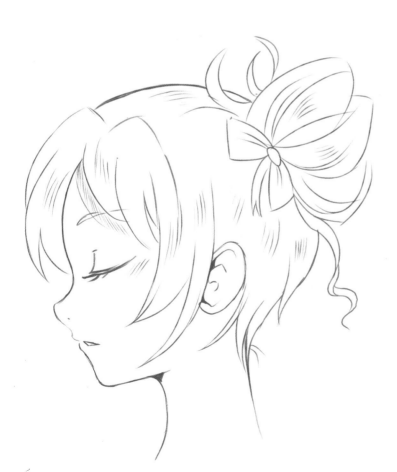

• • • Experiment With Expressions • • •

Experiment with different expressions. In this example the eye is closed, and the lips are slightly open. This indicates the sleepy or melancholy state of the character.

DRAW A FACE, THREE-QUARTER VIEW

Drawing faces at various angles is essential to adding more dynamism and variation to illustrations. Additionally, drawing at such angles is not as difficult as it may seem!

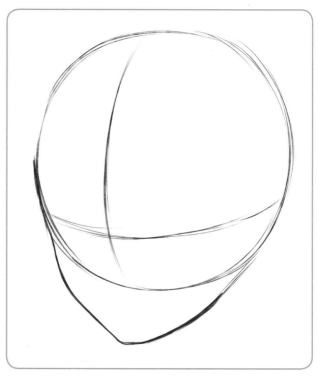

MATERIALS

Surface
drawing paper

Sketching Tools
eraser
mechanical pencil

Optional
white gel pen

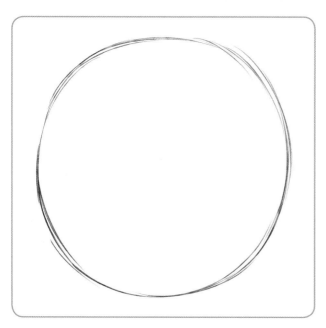

1 Draw a circle.

2 Add a horizontal curvy line close to the bottom of the circle, then draw a vertical curvy line close to the left side. Add the jawline, keeping its middle below the vertical line. It may look a bit funny at this point, but keep going.

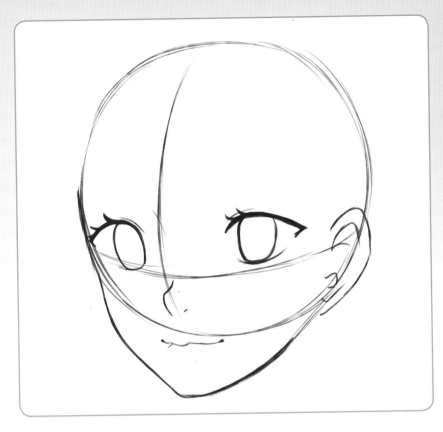

3 Draw two ellipses above the horizontal line and add curvy lines on their upper and lower sides. These will form the eyes. Begin the nose at the point where the curvy guidelines meet, and add lips below. Next, add an ear on the right side of the head. Start at the same height the eyes are placed and end where the nose ends.

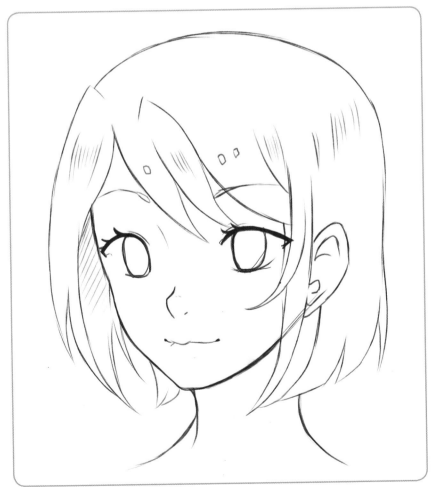

4 Now add the hair. Place eyebrows above the eyes. Add the neck by attaching curvy lines to the head. It is okay to remove the guidelines during this step.

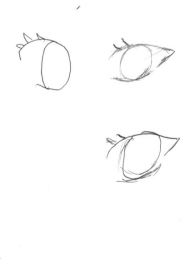

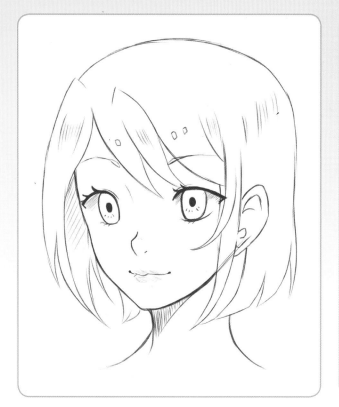

5 Draw pupils in the middle of the eyes. Draw some sunray-like bursts coming out from the pupils towards the lower half of the eye. Add shading to the hair, below the chin, on the lips and around the eyes.

6 Keep shading until you are satisfied with the amount of shadow. Darken the upper half of the eyes. If you wish, add a dot with a white gel pen to make the eye look more alive.

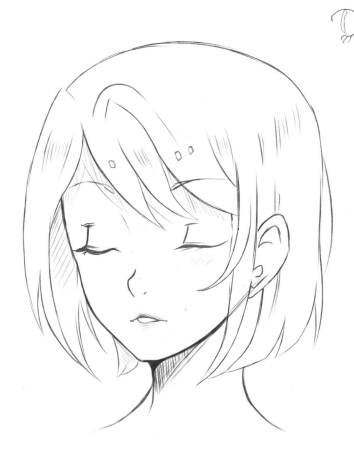

• • • Experiment With Expressions • • •
Try closing the character's eyes and opening the lips slightly to create a different feeling.

MANGA & ANIME STYLE VS. SEMIREALISTIC STYLE

The differences between manga or anime style and a semirealistic one are quite vast. Take a look at these examples to learn how to transform your anime- and manga-style drawings into semirealistic ones.

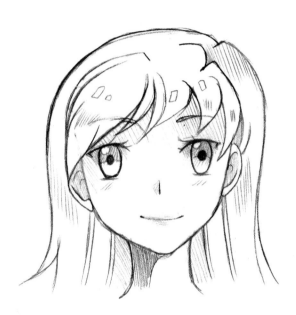

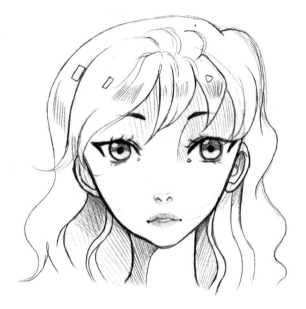

• • • More Depth in Semirealism • • •
The image on the left was drawn in a manga style, while the image on the right applies semirealistic elements and rules to add depth to the face. What other differences do you see?

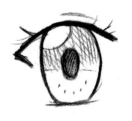

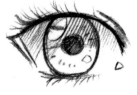

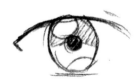

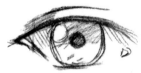

• • • Female Eyes • • •
The main difference between these two styles of eyes is the shape. The manga style on the left features an oval shape, while the realistic eye on the right is rounded and shows more detail. The eyelashes are lusher as well.

• • • Male Eyes • • •
As with female eyes, semirealistic male eyes are much more detailed. Note that male characters usually don't have the rich, thick eyelashes that female characters do.

• • • Noses • • •

When it comes to noses, manga style often features nothing more than lines or dots that are enough to hint at a nose. A semirealistic nose will have both nostrils and shading to give it a more three-dimensional appearance.

• • • Ears • • •

A semirealistic ear will have a greater amount of detail and shading than an ear drawn in the manga style.

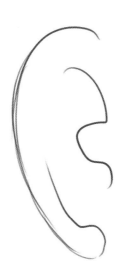

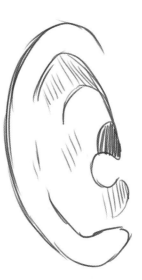

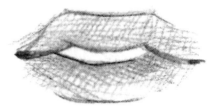

• • • Lips • • •

Manga lips can be portrayed with a simple line, while a semirealistic mouth has larger and more detailed lips.

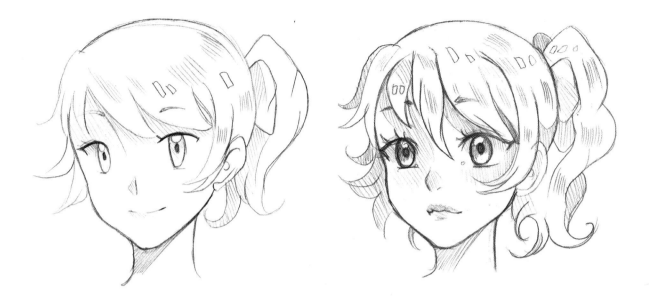

• • • Compare and Contrast • • •

The eyes in the semirealistic version on the right are shaped differently and have more details. The nose is also a different shape. The lips are fuller, and the hair is fluffier with more details.

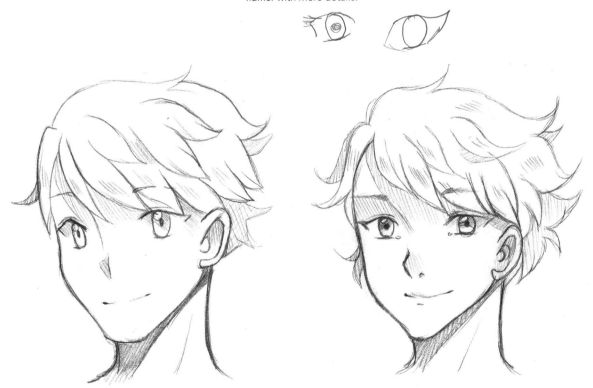

• • • Spot the Difference • • •

In the manga-style version on the left, the hair is softer and the eyes are rounder. The shape of the nose is more defined, and the lips have more detail in the semirealistic style on the right. The way the face is shaded in the semirealistic example also helps to create some depth.

Inking, Shading & Coloring

While many character sketches can have a lot of personality, adding color and shadow will bring even more life to your illustrations. Each artist should develop his or her own unique way of inking, shading and coloring. However, you will find that many artists use the same combinations of common techniques despite their differing styles.

INKING & OUTLINING

Outlining and detailing in ink adds character to a drawing and helps elements stand out. Moreover, it can be used to create interesting patterns, similar to screen tones that appear in each manga.

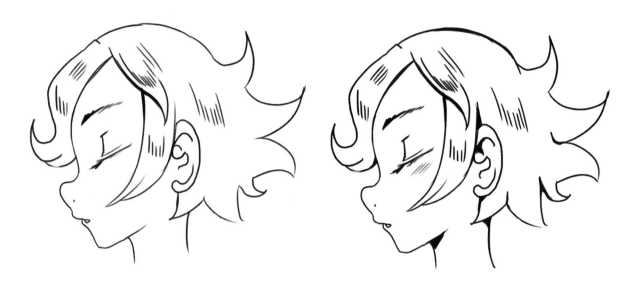

• • • Ink Adds Interest • • •

Compare these two illustrations. The uninked example on the left lacks dynamism and the lines look dull. The inked example on the right has stronger lines and black parts that imitate shadows, making it far more interesting to look at.

• • • Straight Lines • • •

Using straight lines can be a great way of adding patterns to a drawing. Change the height at which you start drawing the lines to create the illusion of waves.

· · · Lines of Varying Direction · · ·

This pattern features lines that go in various directions. It was also made to resemble waves.

· · · Lines Surrounding Objects · · ·

Lines surrounding objects can be used to suggest movement or a glow around the object.

· · · Blending Black and White With Ink · · ·

A blended effect can be created by adding crosshatched lines to the edge of a black area.

· · · Creating Light Effects · · ·

Light effects are used to imitate the rays of sunshine or to create a romantic, fantasy-like atmosphere.

COLOR HARMONY

Choosing the right colors for your illustrations is very important. A color scheme can show a lot about your character's background and be helpful in establishing the depth and dynamics of your picture. There is no limit to the number of color combinations that can work together. However, you may have noticed that some color schemes tend to appear a lot more often than others do. This is due to the fact that certain colors simply work well together because they have a natural harmony with one another.

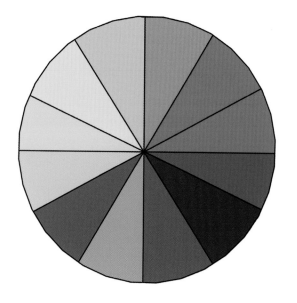

• • • The Color Wheel • • •

This standard color wheel features primary, secondary and tertiary colors. The warm colors are located at the top of the wheel, while the cool colors are at the bottom. It is important to combine various colors from different sides of the wheel so your image won't look too dull. Experiment with various color schemes. Don't limit yourself to just one color range unless you are trying to create a specific effect.

• • • Brown Color Scheme • • •

Brown is a warm color that works well with many other colors, both warm and cool. It often appears with green, orange or pink.

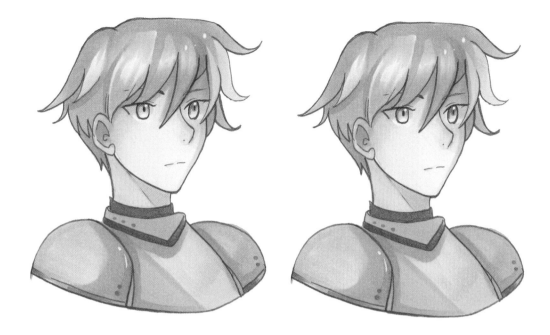

• • • Gray Color Scheme • • •

Gray works well with cool colors, such as blue or blue-green. It can also look interesting with warm hues, such as red or orange. In this example, the man on the left looks like he could be surrounded by snow, while the one on the right could be staring at the sunset.

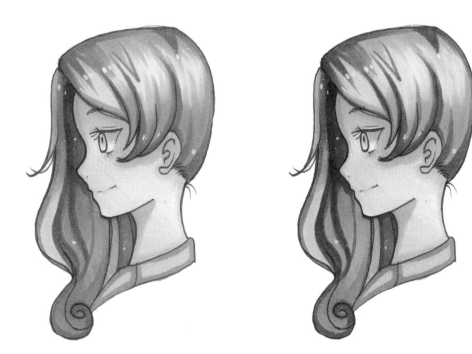

• • • Pink/Purple/Blue Color Scheme • • •

Pink, purple and blue create an aesthetic harmony that is popular with many artists. The darker variation of this image shows heavier-toned colors that also work well together.

DARK INTO LIGHT WITH MARKER

When coloring with markers, there are a few simple coloring and shading techniques you can use to really enhance your illustrations. One of the easiest techniques is to lay down a dark color first, then blend a lighter color over it. Follow the steps below to see how it's done.

MATERIALS

Surface
watercolor paper

Sketching Tools
eraser
mechanical pencil
multiliner pen

Coloring Tools
markers
white gel pen

1 Create a rough sketch, and ink it with a multiliner. Choose any two dark colors to lay down as base colors. They must be dark because you're applying the shadows first. Carefully color around the edges of each element of the face.

2 Now choose brighter colors and apply them directly on top of the darker tones, pressing delicately to blend them. Leave some white areas in the hair for highlights. Fill in the face by layering a light skin tone color over a darker one. Continue until the face, clothes and hair are all filled in.

3 Use any color you like for the hair highlights. In this case, I chose to match them to the clothes and the eyes. Add more tiny highlights on the cheeks and lips using a white gel pen.

LIGHT INTO DARK WITH MARKER

Another common coloring and shading technique is to start with light colors and get darker as you move towards shadows. Follow the steps below to learn the process.

MATERIALS

Surface
watercolor paper

Sketching Tools
eraser
mechanical pencil
multiliner pen

Coloring Tools
markers
white gel pen

1 Create a rough sketch, then ink it with a multiliner. Use a light color of your choice to fill in the face. Then softly fill in the middle areas of the hair and those closest to the edges. Leave some parts of the hair white.

2 Choose a medium-dark color and fill in the white areas of the hair. Blend it delicately into the areas where the lighter color is. Add shadows to the face and along the hairline.

3 Choose the darkest color and apply it in the areas where the darkest shadows are. Use a white gel pen to add small highlights to the hair. Outline the illustration with a multiliner to make it stronger and sharper.

Tip

It's okay to use both techniques in the same illustration. Sometimes one technique works well for certain elements of an illustration, while another works better with the other elements. For example, you can color hair by applying the light-to-dark method, and color skin by going dark to light. Don't be afraid to experiment until you find the techniques that work best for you.

BLEND SKIN TONES WITH MARKER

Coloring skin tones is not as difficult as it may seem. You can use various color combinations to create characters of different ethnic origins or even a unique fantasy species. Follow the steps to see how simple the process can be.

MATERIALS	
Surface	watercolor paper
Sketching Tools	eraser mechanical pencil multiliner pen
Coloring Tools	markers white gel pen

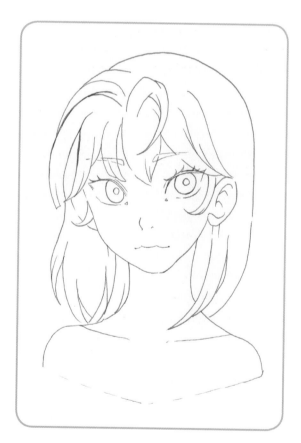

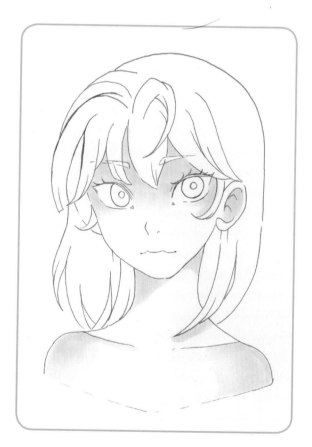

1 Create a rough sketch and then ink it with a multiliner. (Note that for this character, I used thicker lines for the eyelashes and in the corners where hair strands meet to make her look more lively.)

2 Choose three flesh-colored markers in light, medium and dark tones. Apply the medium-toned marker delicately to mark the shadow areas on the shoulders, neck, forehead and mask of the face.

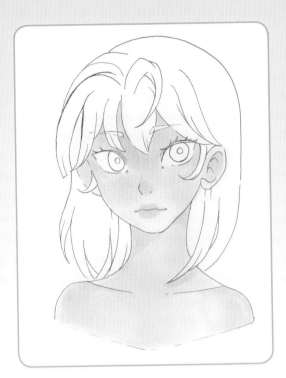

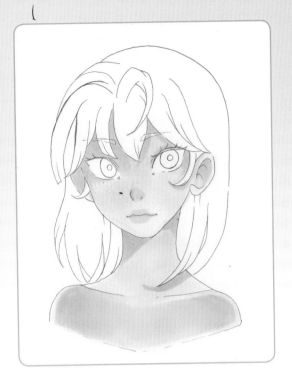

3 Quickly color in the entire skin area with the light-toned marker. Then switch back to the medium tone and gently apply another layer across the nose and mouth. Define the line of the nose by shading the space under the left eyebrow.

4 Add shadows by firmly applying the darkest color to the same areas as in Step 2. Then use light pressure to add a shadow on the nose and mouth. Softly color over the entire area with the middle-tone marker to blend it all together.

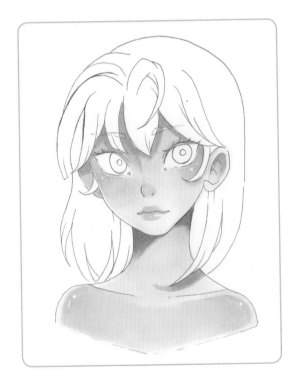

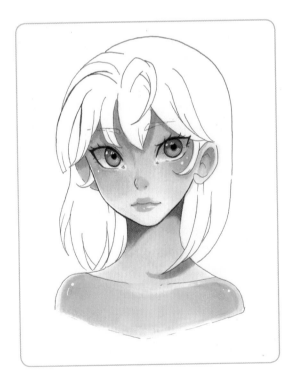

5 Use a complementary color, such as dark purple, to add final shadows under the hair, on the neck and in the ears. Add blush by softly applying red marker to the cheeks and quickly blend it with the middle flesh color.

6 Use a white gel pen to add small dots and lines on her lips, nose, cheeks and shoulders to create highlights.

◇ DEMONSTRATION ◇
ADD COLOR WITH WATERCOLORS

Now let's explore how to make your characters' clothing more dynamic with watercolors. If you keep a few simple rules in mind, the process can be fun and nearly effortless. Follow the steps to learn how it's done.

MATERIALS	
Surface	watercolor paper
Sketching Tools	eraser mechanical pencil multiliner pen
Coloring Tools	watercolor brushes watercolor paints white gel pen

1 Use a multiliner to prepare your line art, in this case, a dress. Erase any leftover pencil marks and make sure there is no debris left on the paper. Color the area with your chosen watercolor paint. Take your time and be careful so you can control the paint and keep it inside the outline.

2 Choose a darker tone of the same color and add fluffy shapes to the dress. Focus on the areas where shadows would lie, such as the chest, armpits, stomach and in the folds of the fabric.

3 Wait for everything to dry, then continue softly adding shadows with the darker color in the same areas as the previous step.

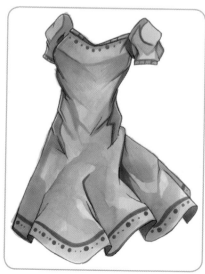

4 Use your brush like a marker by dipping it into the darker color and then slowly adding final shadows in the folds of the fabric, the armpits and under the dress. Use a marker to add a decorative pattern to the bottom of the dress.

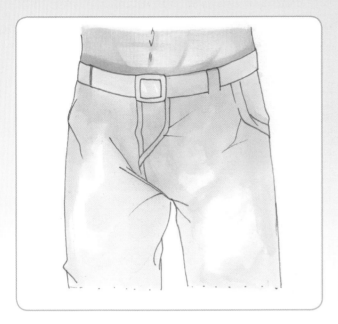

1 Sketch your version of pants or jeans, and then outline with a multiliner. Make sure the sketch is clean and ready to be colored before proceeding. Gently cover the area with a blue watercolor pigment. Remember it doesn't have to be colored evenly. Don't add more layers until everything is dry.

2 Once dry, apply another layer of watercolor in the shadow areas to add definition. Let it dry.

3 Apply another layer of watercolor that fully covers the pants, then begin defining the shadows in places where the fabric folds. Add shadows on the pocket, belt and zipper.

4 Once dry, apply another layer of watercolor. Your goal here is to build up a strong, rich color, so continue adding layers until you are satisfied with the result. Add more details by darkening the shadow areas. Outline with a multiliner and use a white gel pen to add final details.

1 Sketch a shirt and prepare clean line art. Gently apply watercolor to fill in the area with your chosen base color. Let dry.

2 Apply another layer of darker watercolor to create the shadows. Focus some attention on the areas around the armpits and folds of the fabric. Let dry.

3 Continue adding and defining shadows in the areas under the arms, around the buttons and in the corners. Let dry.

4 Slowly apply the darkest shadows under the collar, in the armpits, around the buttoned part of the shirt and anywhere else that seems natural. Try to use your brush as if it were a marker—dip it in paint, but don't apply too much water. Once dry, outline with a multiliner to create a sharp effect.

1 Sketch a skirt and prepare clean line art. Make sure there are no traces of pencil left. Fill the area with the first layer of your chosen watercolor. It doesn't have to be even at this point, so don't worry about making it look perfect.

2 Wait for the first layer to dry, then add another layer to build up the color. Let it dry, then begin adding shadows in the areas where the fabric folds. Do this carefully and delicately.

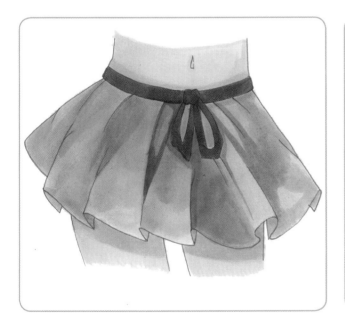

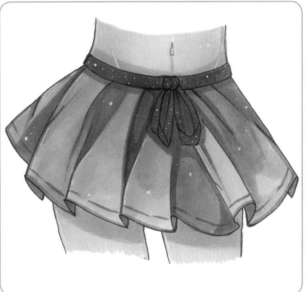

3 Choose a darker color and slowly cover the lower part of the skirt and the areas where the fabric folds. Color the belt in with black watercolor or marker.

4 Wait for all the layers to dry, then add more shadows in the folds of the fabric. Add a small pattern to the lower part of the skirt. It can be anything—flowers, stars, dots, etc. Use a white gel pen to add speckles for aesthetic value. Finish by outlining with a multiliner.

COMBINING MEDIUMS

There are various elements of your illustrations that can be greatly enhanced if you combine different mediums when adding color. Marker and watercolors especially complement each other, resulting in a much smoother transition of colors in your illustrations.

• • • Compare Watercolor Base Versus No Watercolor Base • • •
The example on the right has a watercolor base with marker layered on top of it. The example on the left is layered marker without a watercolor base. Notice how much smoother the example with the base layer of watercolor looks.

• • • Brush Care and Maintenance • • •
I cannot stress enough how important it is for you to keep your watercolor brushes clean. Each time you finish painting, place them in cold water. Remember not to leave them there for too long, though, or the tips will get damaged. Wipe them dry with a paper towel and leave them to rest until next time.

Also, don't forget to seal your watercolor tubes when you finish a painting session. If they go dry it's not the end of the world, since adding water brings them to life. However, you do not want them to get dusty.

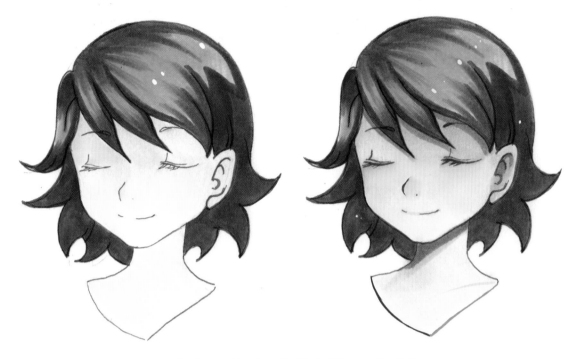

• • • Do Not Layer Marker Until the Watercolor Is Dry • • •

Watercolors work very well as a base for coloring skin. Just remember to apply the base layer delicately, and wait until after it has thoroughly dried before you begin adding more depth with markers. Never layer marker over wet watercolors, as this will result in muddy colors and ugly smudges. Waiting until the watercolor base has dried will ensure that the mediums blend smoothly.

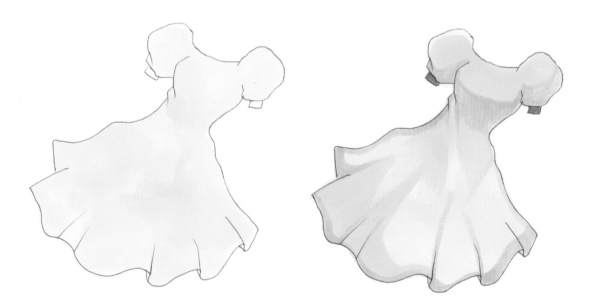

• • • Stick With Similar Colors and Hues Across Mediums • • •

You can choose any watercolor pigment you like to lay down as the base layer of color. However, you will need to pick a similar color in a darker hue when you layer the marker and add shadows. As a bonus, using watercolors as a base will also save your precious marker ink!

◊ DEMONSTRATION ◊

COLOR HAIR WITH MARKER & WATERCOLORS

Let's explore how to color hair by combining watercolors and markers. Mixing two different mediums may seem like it would complicate the process, but if you follow the steps, you'll see how it can actually make things easier.

MATERIALS

Surface
watercolor paper

Sketching Tools
eraser
mechanical pencil
multiliner pen

Coloring Tools
markers
watercolor brushes
watercolor pigments
white gel pen

1 Prepare a sketch with a pencil, and then outline it with a multiliner. Erase the pencil marks after you have finished outlining.

2 Start by painting in the area with watercolors. In this exercise, we are going for brown hair, so you'll need to use yellow as the base color. Laying down watercolors now will give the markers a smoother and more covered area for blending later.

52

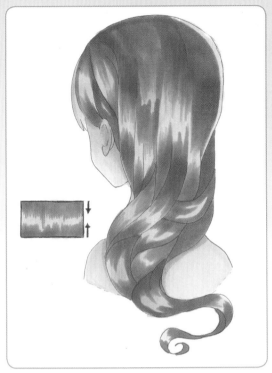

3 Now use a marker to add the color of hair you want, in this case, brown. Press strongly and release the pressure to create shiny areas by leaving some parts uncolored. You can see the direction of strokes in the example.

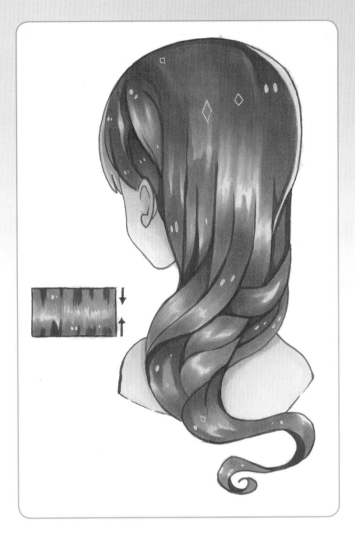

5 Outline the drawing with a dark marker and strong pressure. Follow the direction of strokes and leave space for brighter parts. Add highlights with a white gel pen. Outline the drawing again with a multiliner.

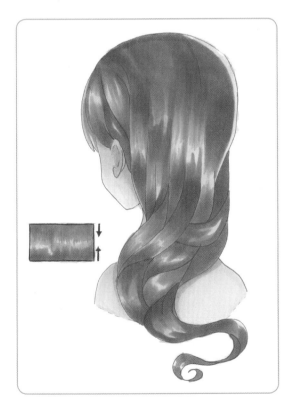

4 Add another layer of color with a lighter marker to blend the darker color into the yellow background. This will create a smooth transition.

Surface
watercolor paper

Sketching Tools
eraser
mechanical pencil
multiliner pen

Coloring Tools
markers
watercolor brushes
watercolor paints
white gel pen

Optional
silver pen

◦ DEMONSTRATION ◦

COLOR A SKY WITH MARKER & WATERCOLORS

Continue combining marker and watercolors as you follow the steps to color a whimsical sky.

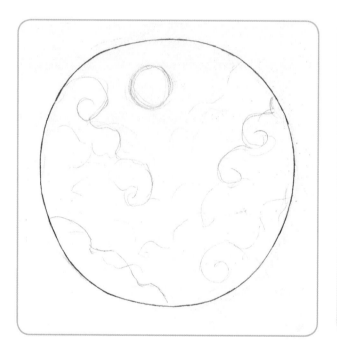

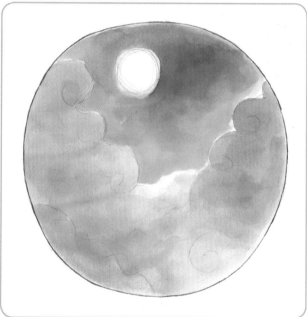

1 Draw a circle. Outline it with a multiliner. Sketch the sky in the middle of the circle by adding a small circle that will be the moon and fluffy shapes that will be the clouds.

2 Fill the area around the moon with blue watercolor pigment. Then use purple to paint the top of the clouds and pink for the middle part of the clouds. Apply orange and yellow to the bottom of the clouds. Remember that the quicker you apply the colors, the better they will blend together.

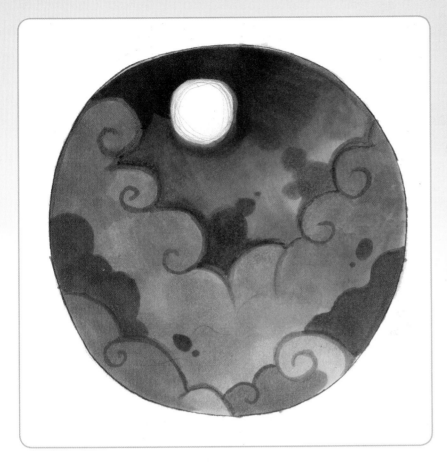

3 Let the watercolors dry. Now that the watercolors have provided some guidelines, it's time to use markers. Choose similar colors to the watercolor pigments you used and begin layering them on top of the paint—blue on blue, purple on purple and so on. Apply firm pressure to add dark dots and cloud-like shapes in the distance.

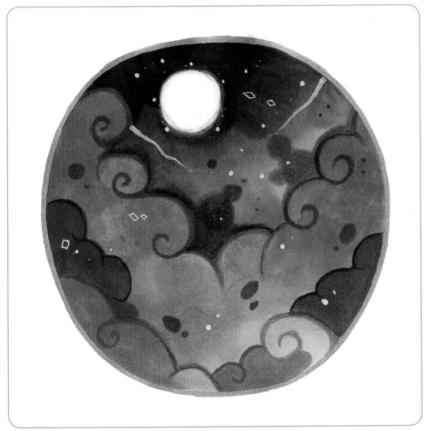

4 Outline the clouds with a dark-colored marker. Create stars and shiny highlights by adding white dots with a gel pen. Add additional small dots around the moon to make it look like it's shimmering. Use a silver pen to create a frame around the image if you wish.

USING DIGITAL TOOLS FOR ENHANCEMENT

Digital tools can be very helpful, even when it comes to traditional art. If you make a mistake, there is always a chance you can fix it after scanning your image. Some of the most popular software, such as Photoshop and SYSTEMAX's PaintTool SAI, have many useful options that can help you enhance your artwork.

• • • Replace Color Option • • •

With the Replace Color option, you can alter certain colors to make them darker or brighter, or you can change them completely. This tool is especially useful for altering color in small areas, like if you wanted to change the eye color of a character.

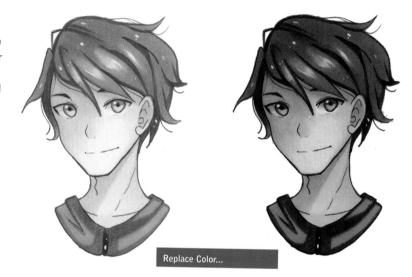

Replace Color...

• • • Lowered Brightness, • • • Raised Contrast

Lowering the brightness and raising the contrast can help make your colors more vivid and bring them to life.

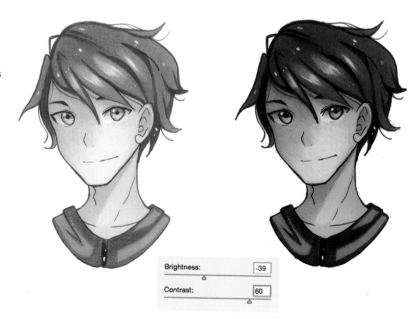

Brightness: -39

Contrast: 60

56

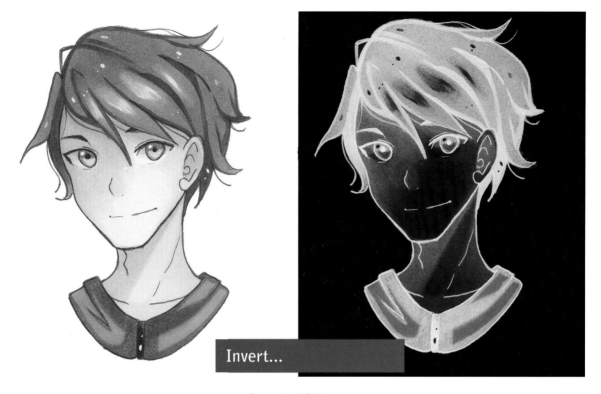

Invert...

• • • Inverted Colors • • •

Inverting your colors works very well if you are trying to achieve a ghostly look.

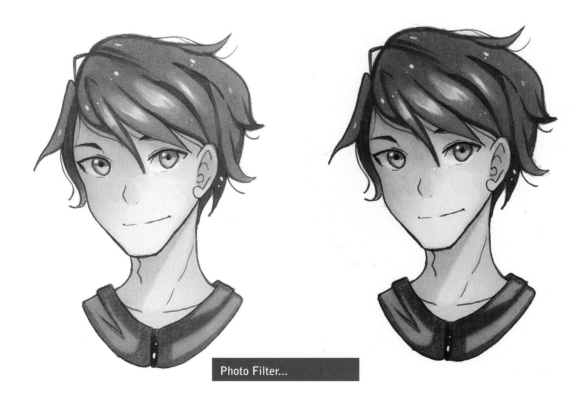

Photo Filter...

• • • Photo Filters • • •

Photo filters can add warmth or coolness to your illustrations.

Creating Backgrounds

Backgrounds play an important role in the composition of all artwork. Beyond simply providing the location and setting, backgrounds can be used to aid in storytelling and help set the mood of a scene. Backgrounds can even serve as a compositional element your characters can react to or interact with.

PLANNING A BACKGROUND

Building interesting compositions is very important in artistic storytelling. Planning the elements of your background will help you to tell an interesting story without using any words and will be a great asset in catching the viewer's attention. Let's analyze the sketch below to get a better understanding of what you'll need to consider when planning a background for your composition.

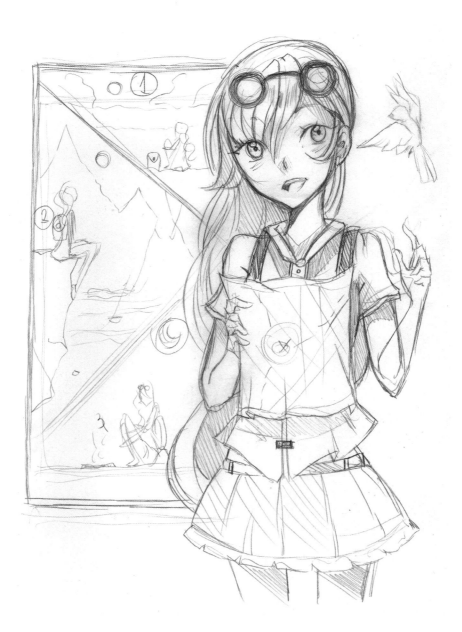

• • • Background Considerations • • •

This illustration portrays an adventurous girl set against a background that is divided into three areas. Each part shows a different stage of her journey. Think about what you would include in each section based on the kind of story you want to tell. Avoid using speech bubbles and focus on using wordless narration in your art. Consider the framing options that would work best for this piece. And don't be afraid to experiment with ideas and random doodles while you are in the sketch phase of your composition.

The completed illustration features the figure of the girl as the main focal point. The background shows the particular steps of her journey. If you divide your background, try to vary the sections but also make their connection clear for smooth storytelling. In this case, it's the particular phases of a day—twilight, midday and nighttime, but the possibilities are endless! Try to create art stories that leave room for interpretation. These are usually the most relatable for the viewers.

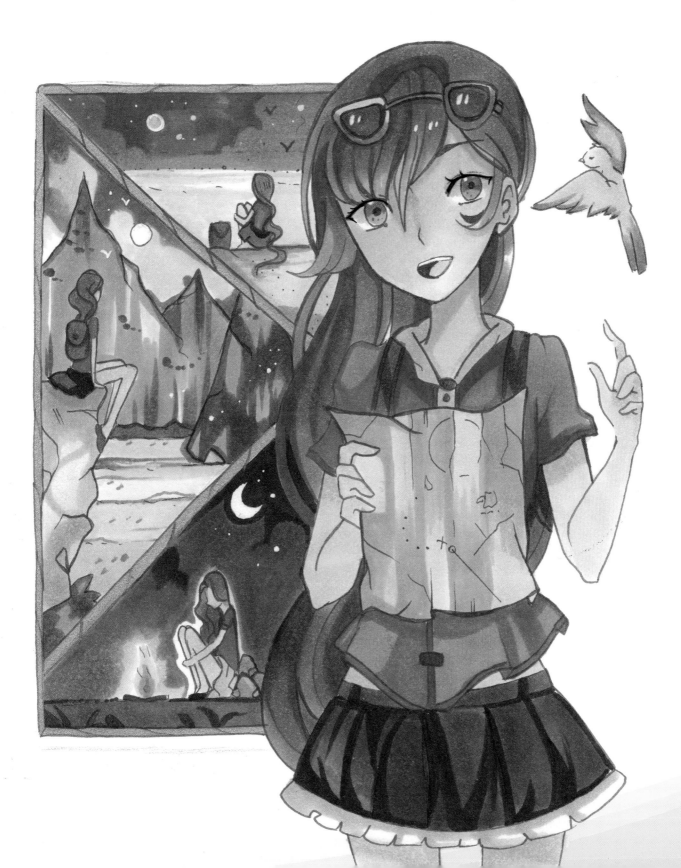

MATCHING CHARACTERS WITH BACKGROUNDS

It is important for the background to match the character, so to speak. Here are some tricks you can use to make that happen.

Tip

Feel free to explore and experiment with various color schemes, but keep in mind not all colors work well together. Always remember to highlight the character with similar colors to those that you are planning to use for the background! Plan the background colors ahead of time to make your workflow smoother.

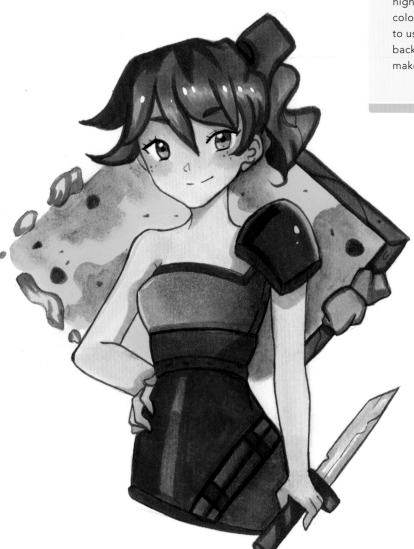

• • • Complementary Elements Work Together • • •

Take a look at this forest warrior girl. The gray, green and brown colors work well together and complement the concept behind the character. Observe how the frame consists of wooden planks and rocks that match the colors of the character. The small dagger she holds matches the rocks that were added to the frame. The background is yellow-green, which works well with her outfit. The small flames on the left suggest she uses spells. The leather elements of her outfit are also complemented by the dagger, the planks and her hair color.

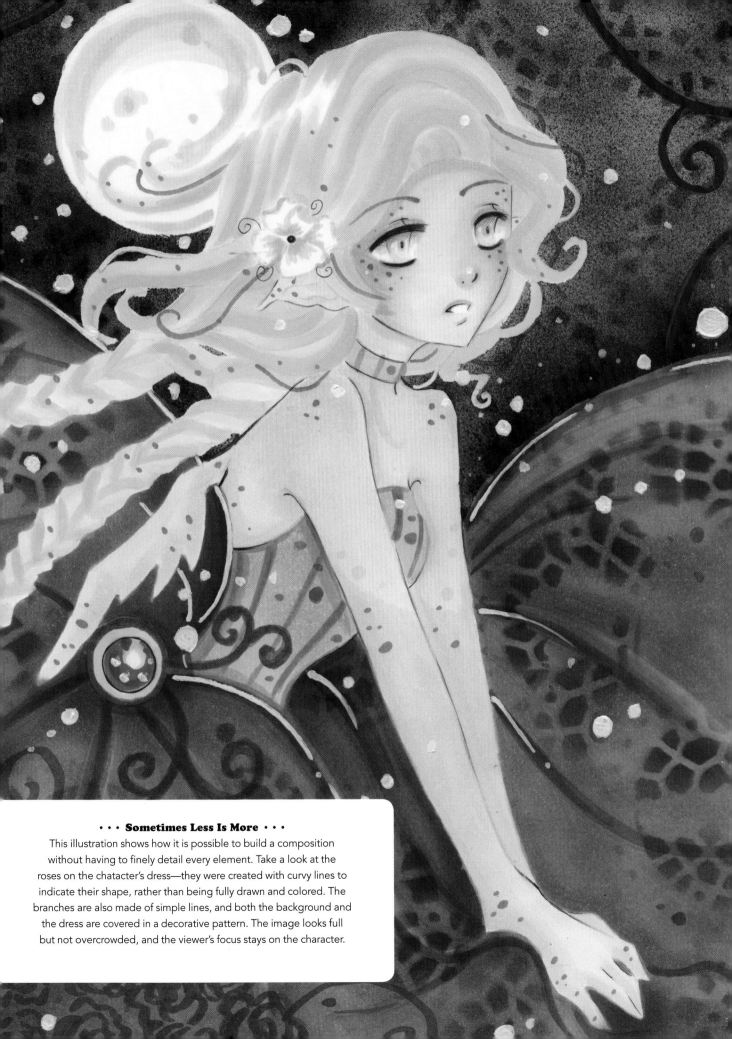

• • • Sometimes Less Is More • • •

This illustration shows how it is possible to build a composition without having to finely detail every element. Take a look at the roses on the chatacter's dress—they were created with curvy lines to indicate their shape, rather than being fully drawn and colored. The branches are also made of simple lines, and both the background and the dress are covered in a decorative pattern. The image looks full but not overcrowded, and the viewer's focus stays on the character.

VARIOUS BACKGROUND ELEMENTS

In order to make your compositions more attractive, include a variety of elements as a part of the background. Take a look at the examples below to see how you can color such elements in very short steps.

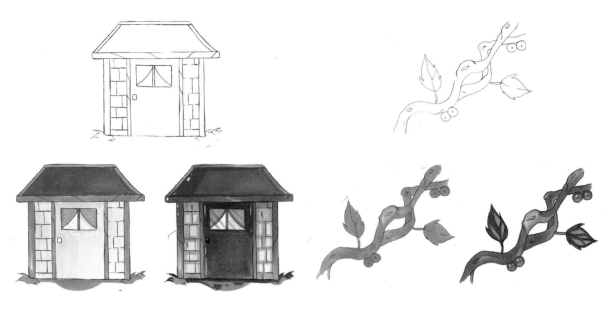

• • • Buildings • • •

Use a multiliner to prepare lineart of a building, then use markers to add the first layer of color by filling in each area softly with a bright color. Then choose darker colors to add the shadows. Finally, apply white gel pen for the highlights.

• • • Branches • • •

Use a multiliner to create line art of a tree branch, then color the branch with a brown marker. Color in leaves with green and add red for the berries. Choose darker colors to add shadows on branches, veins on leaves and depth to the fruit.

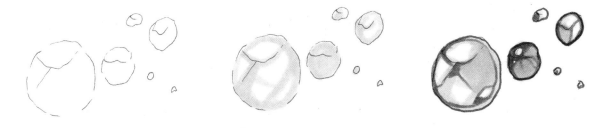

• • • Water • • •

Use a multiliner to create line art of drops or beads of water. Outline it internally with blue paint or a blue marker. Use a darker blue marker to add more outlines that will define the water's shape. Leave white areas to create the effect of reflections.

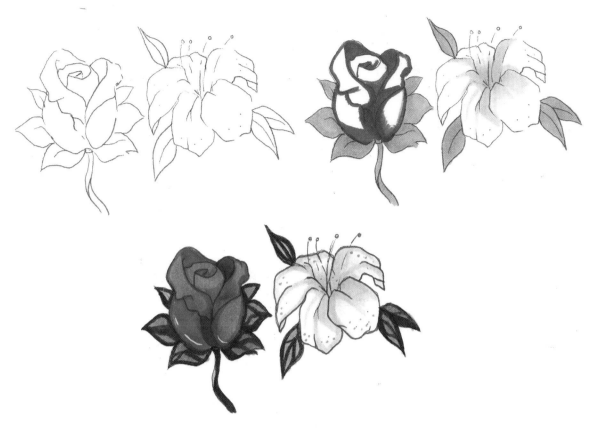

• • • Flowers • • •

Prepare line art of a flower with a multiliner. Color the leaf area with a green marker.
Gently add a dull red base color to the flower. Add veins to the leaves with a dark green
marker, then color the flower with a brighter red. Outline the flower with a multiliner.

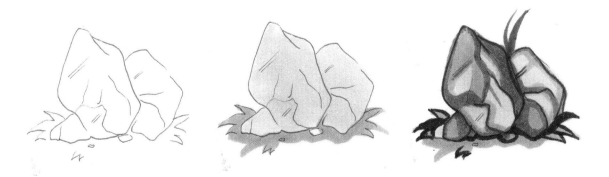

• • • Rocks • • •

Prepare line art for rocks. Color the rocks with warm gray and add a base layer of green
to the grass. Use a darker warm gray tone to add details to the rocks and grass. Outline
everything with a multiliner.

FRAMING

Adding your finishing touches to a composition is an important process in finalizing a piece of art. Below are some examples of various styles of frames you can use to close your compositions. Do not limit yourself just to what you see on this page, however. There are many more options just waiting to be created.

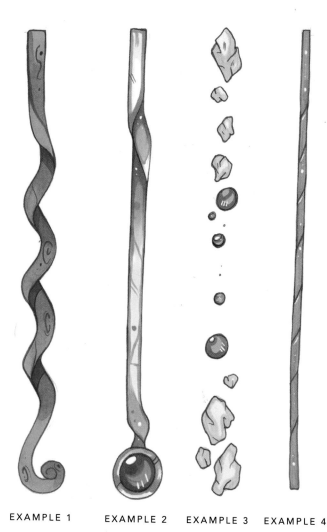

EXAMPLE 1 EXAMPLE 2 EXAMPLE 3 EXAMPLE 4

• • • Framing Style Options • • •

Example 1 is a standard wooden frame that works well for various whimsical compositions, as well as compositions connected to nature.
Example 2 is good for fantasy or shojo art. The jewels can be modified, reshaped and recolored to suit the needs of any illustration.
Example 3 consists of scattered stones and jewels. It can match a variety of compositions ranging from a fantasy concept to an illustration featuring a day at the beach. The jewels can be replaced with any type of embellishment.
Example 4 is a standard frame that matches pretty much anything. It can be tweaked to suit your vision.

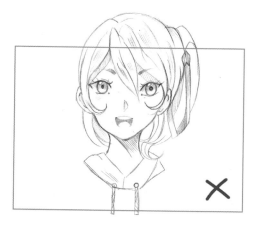

• • • Bad Framing Position • • •

The bad framing in this example looks unnatural and chops off the head in an awkward way.

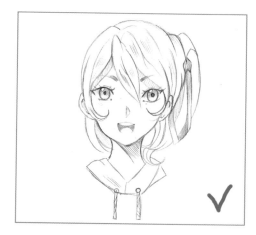

• • • Better Framing Position • • •

This standard framing position keeps some distance between the girl and the borders of the frame, which is generally the best practice when framing subjects within your composition.

DRAW A FRAME

Follow the steps to draw a frame for your illustration.

MATERIALS

Surface
watercolor paper

Sketching Tools
eraser
mechanical pencil
multiliner pen

Coloring Tools
markers
white gel pen

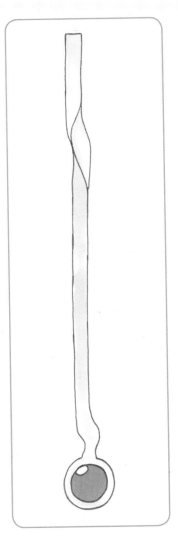

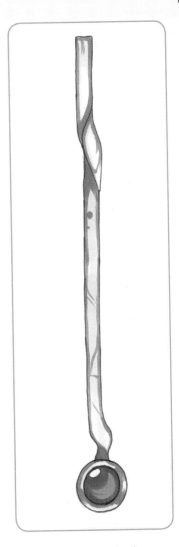

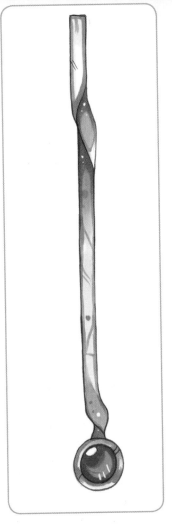

1 After you have created your line art with a multiliner, add basic color to the frame. In this case, we are going for a stone-like look and a jewel, so gently apply light gray and red to the image. Leave a white dot in the upper left part of the gem.

2 Use a darker shade of gray to add shadows in the corners. Outline the jewel with dark red. Be careful not to let the ink bleed across the lines.

3 Pick up another shade of gray and blend the darker parts with the lighter ones. Apply a darker red shade to the gem. Add highlights with a white gel pen.

COLOR A
BACKGROUND

Follow the steps to learn how to paint background
scenery quickly and efficiently.

MATERIALS

Surface
watercolor paper

Sketching Tools
eraser
mechanical pencil
multiliner pen

Coloring Tools
watercolor brushes
watercolor paints
white gel pen

1 Create a pencil sketch of a landscape scene with buildings. It can be messy at this point. Use a multiliner to outline the significant elements, such as any trees, hills or buildings.

2 Add base colors to the buildings and hills. You can use any technique you like here—whether you start with bright colors and then add shadows or the other way around. It's completely up to you and what you're comfortable with.

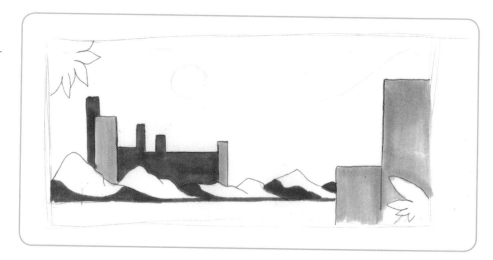

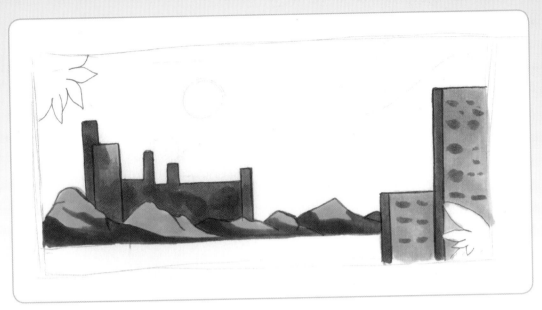

3 Add small details to the buildings by creating dots of various size. They will create distant windows. Continue to add color to the hills.

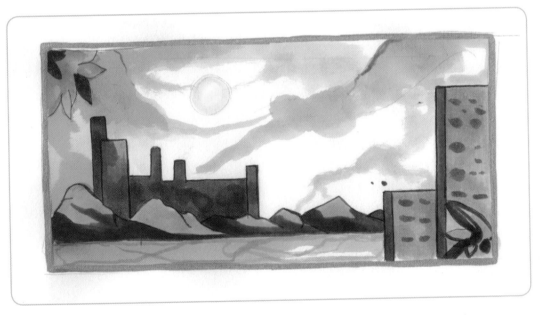

4 Use blue watercolor pigment to paint random shapes in the sky. Leave some white space here and there—this will quickly create clouds. Color in the water and add a few lines to create waves. Color in the trees in a similar manner as you colored the hills. Add some yellow to make a shining sun.

Tip

Add a frame around your composition to make it look neat and clean. You can use different color schemes to portray various hours of a day. Try painting the sky and water with purple, pink, red and orange to create a twilight feel.

CREATE ATMOSPHERE WITH LIGHT

You can use light to create interesting effects and atmosphere in your illustrations. It is easier than it looks. Follow the steps to recreate the example on the next page.

MATERIALS

Surface
watercolor paper

Sketching Tools
eraser
mechanical pencil
multiliner pen

Coloring Tools
markers
white gel pen

1 Create a rough sketch with a pencil and then outline it with a multiliner. Think about the composition considerations for a night setting. Later, you will create some night glow with markers.

2 Color the skin with a base layer of a light-colored marker. Layer over that with a darker color, pressing strongly to blend everything together. Use a light blue marker to add highlights to the hair and on the left side of the character.

3 Color in the hair, eyes and clothes. Use darker colors that will help the light blue hue stand out. It is okay to color the clothes using just one marker for each part, but keep in mind that the more color you use, the more detailed the picture will be.

4 Color the background with dark colors at the top and brighter colors at the bottom. Leave some white circles around the character. Press strongly with a light blue marker to color in the circles—these are our shining fireflies. The blue hue on the character helps the viewer imagine that the glow of the fireflies is illuminating her. Add a decorative frame to close the composition.

Tip

While creating glow, use darker colors around the glowing elements to make them stand out.

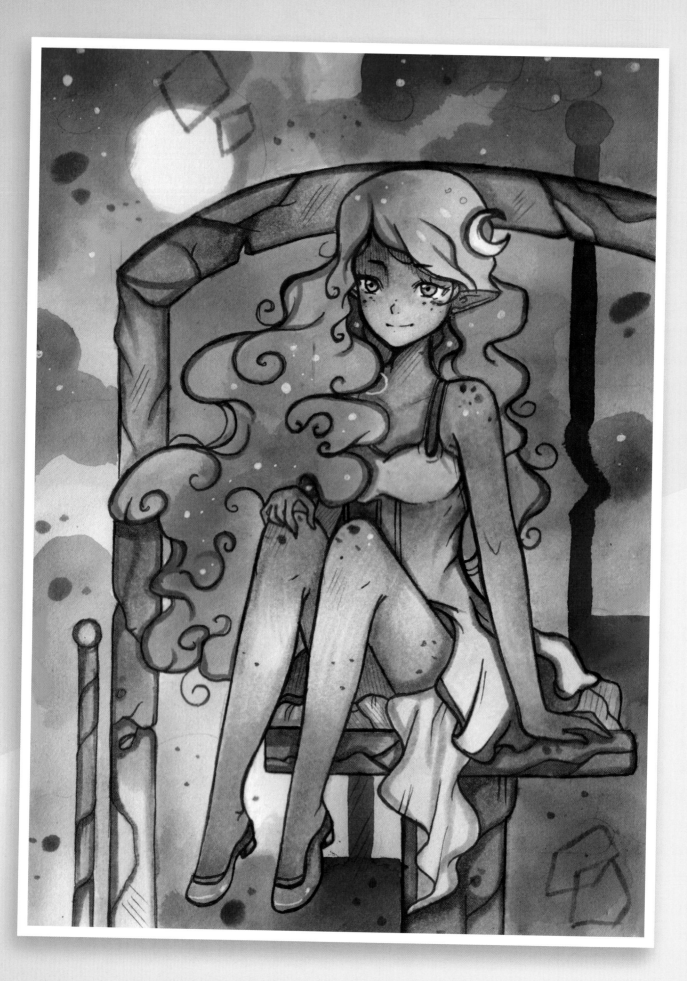

. CHAPTER .

Inspiration & Creativity

. FOUR .

Creativity is a skill that can and should be exercised just as much as technical drawing and painting skills. Your creativity is what will help you build interesting compositions and carry out engaging storytelling. It also plays an important role in avoiding artistic blocks. As I like to say, "A sketch a day keeps the art block away!"

BUILDING COMPOSITIONS

Use the following examples as inspirational guides for developing your own unique compositions. Just relax and let yourself have some fun with it.

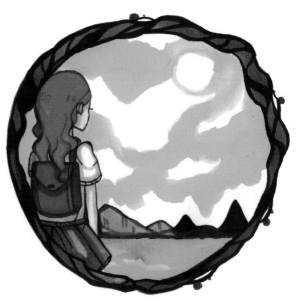

· · · Surrounding Frame · · ·

Although the character is inside this frame, the focal point is the landscape. This makes it appear as if the viewer is observing the scene right alongside the girl. This particular composition is surrounded by a circular frame, but it could work with any shape you choose.

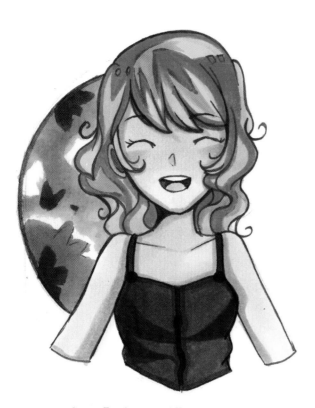

· · · Background Frame · · ·

A frame that holds the background elements has been placed behind the character. Various hues of green were used to tie everything together to make it work.

Tip

If a drawing doesn't fill the entire sheet of paper, it makes sense to "close" the composition somehow. We have already discussed various framing options, so put this newfound knowledge into action!

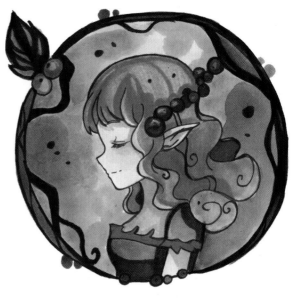

· · · Attached Frame · · ·

This blueberry fairy character is connected to the background by her crown, which is attached to the frame. Complementary colors were chosen in hues that give the image a vintage look.

COMBINING COMPOSITIONAL ELEMENTS

Now it's time to put your creativity to the test! Take a look at the various elements provided across the following pages and try to put them all together to create your own composition.

Natural Elements

BRANCH

LEAF

MOON

WATER DROPLETS

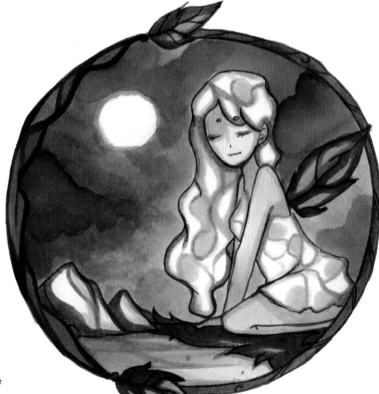

• • • Nature-Inspired Composition • • •

The given elements were used to create a scene with a small water fairy. The branches create the frame of the composition. The leaves were used as decorative elements for the frame, as well as for the fairy's wings. The moon is visible in the night sky.

Fantasy Elements

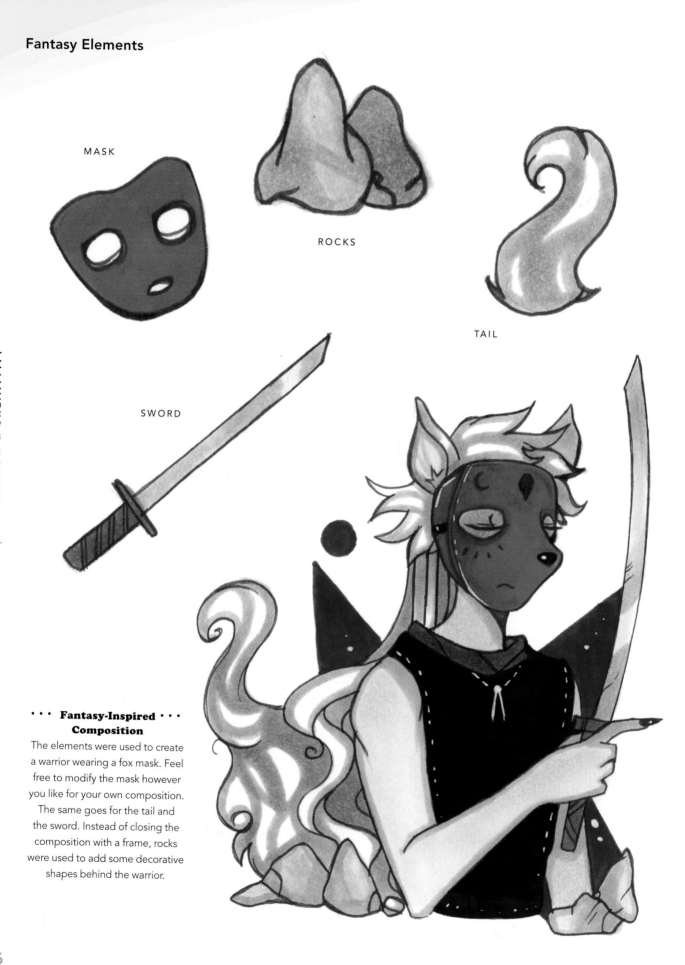

MASK

ROCKS

TAIL

SWORD

• • • Fantasy-Inspired • • •
Composition

The elements were used to create a warrior wearing a fox mask. Feel free to modify the mask however you like for your own composition. The same goes for the tail and the sword. Instead of closing the composition with a frame, rocks were used to add some decorative shapes behind the warrior.

Astronomy Elements

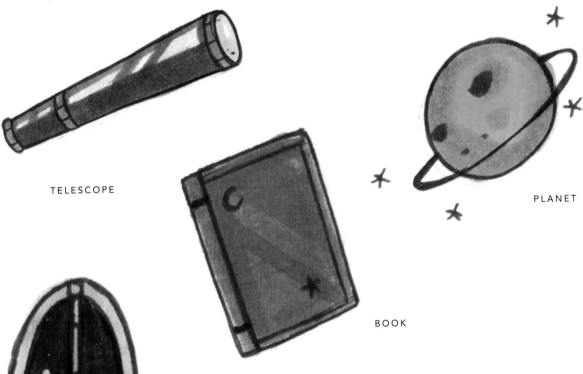

TELESCOPE

BOOK

PLANET

WINDOW

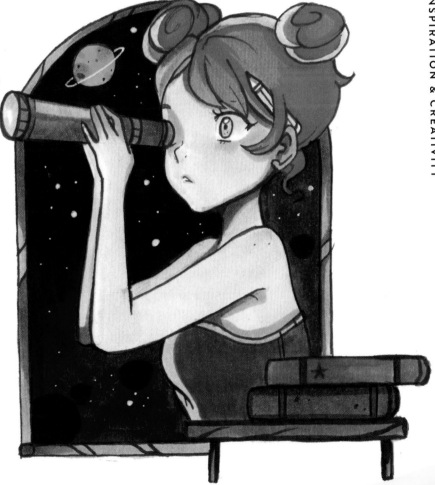

• • • Astronomy-Inspired • • •
Composition

In this scene, the elements were combined to show a girl observing the night sky with her telescope. The books rest upon a small table. You can see the planet in the distance, and the window was used as a background.

GIJINKAS

Gijinkas are personifications of food and drink, elements in nature, inanimate objects and even abstract concepts. They are one of the most useful and creative concepts in character design because you can design a gijinka from just about anything—a banana, a flower, a car—the possibilities are endless!

Although creating the personification of abstract concepts may seem harder than personifying objects,

that doesn't have to be the case. Abstract ideas such as love, friendship or happiness may be interpreted by each individual, which means there is no one right (or wrong) way to do it. Our choices may also reflect who we are inside, which is a great asset of being an artist.

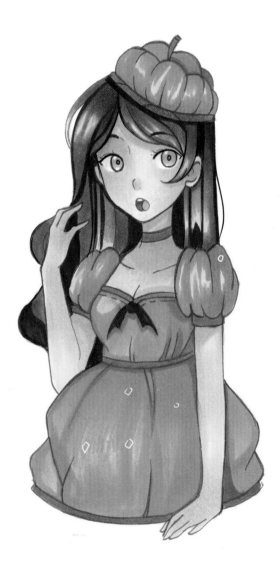

• • • Pumpkin Gijinka • • •
This character's outfit is based on a pumpkin. Her hair is black, which complements the orange and relates to Halloween. Her ribbon resembles a bat for this same reason. Brown was used as additional color for details, and her green eyes represent the color of the vines that pumpkins grow on.

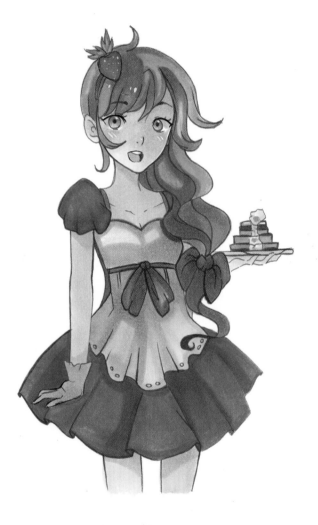

• • • Strawberry Pancake Gijinka • • •
The strawberry is the main focus, and the character's hair is brown to resemble the color of pancakes. When you create characters, think about which complementary colors will work best for the main subject. In this case green was used for the belt and ribbon. Adding finishing touches, like the apron, completes the design.

Now try to reverse the focus and create a gijinka where the pancake would be the main subject instead.

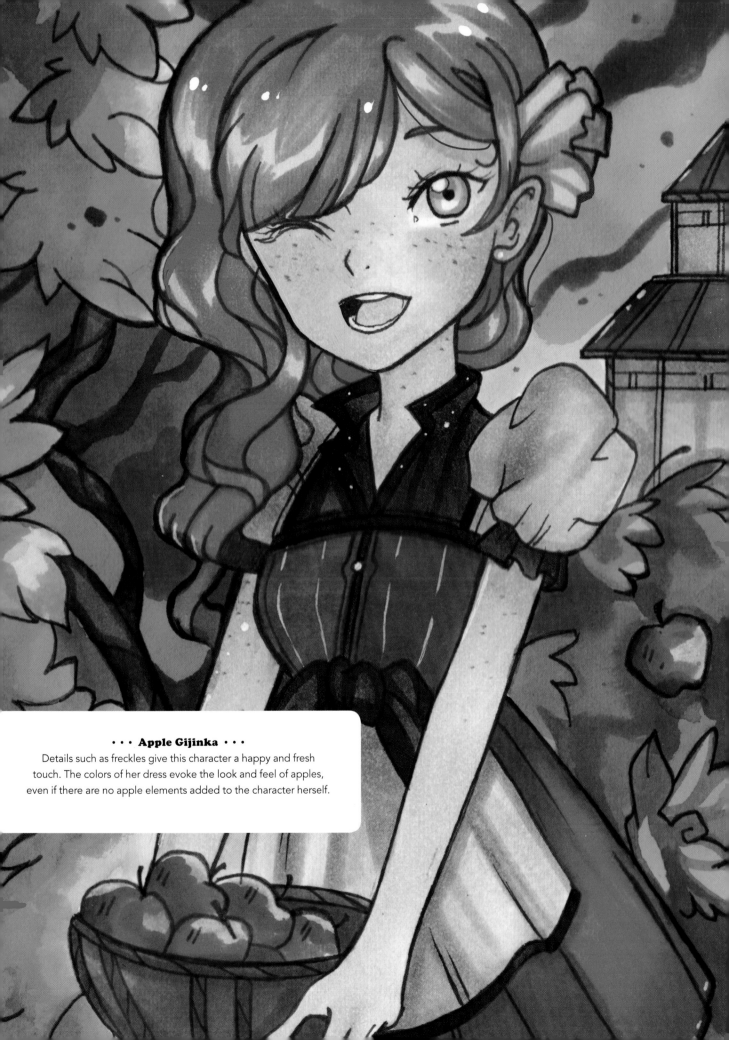

• • • Apple Gijinka • • •

Details such as freckles give this character a happy and fresh touch. The colors of her dress evoke the look and feel of apples, even if there are no apple elements added to the character herself.

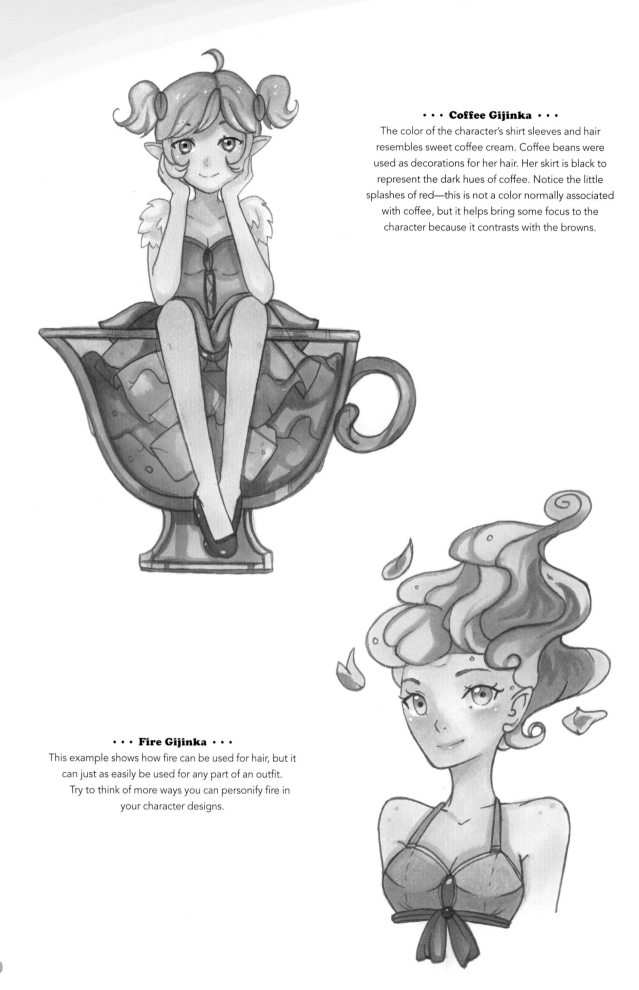

• • • Coffee Gijinka • • •

The color of the character's shirt sleeves and hair resembles sweet coffee cream. Coffee beans were used as decorations for her hair. Her skirt is black to represent the dark hues of coffee. Notice the little splashes of red—this is not a color normally associated with coffee, but it helps bring some focus to the character because it contrasts with the browns.

• • • Fire Gijinka • • •

This example shows how fire can be used for hair, but it can just as easily be used for any part of an outfit. Try to think of more ways you can personify fire in your character designs.

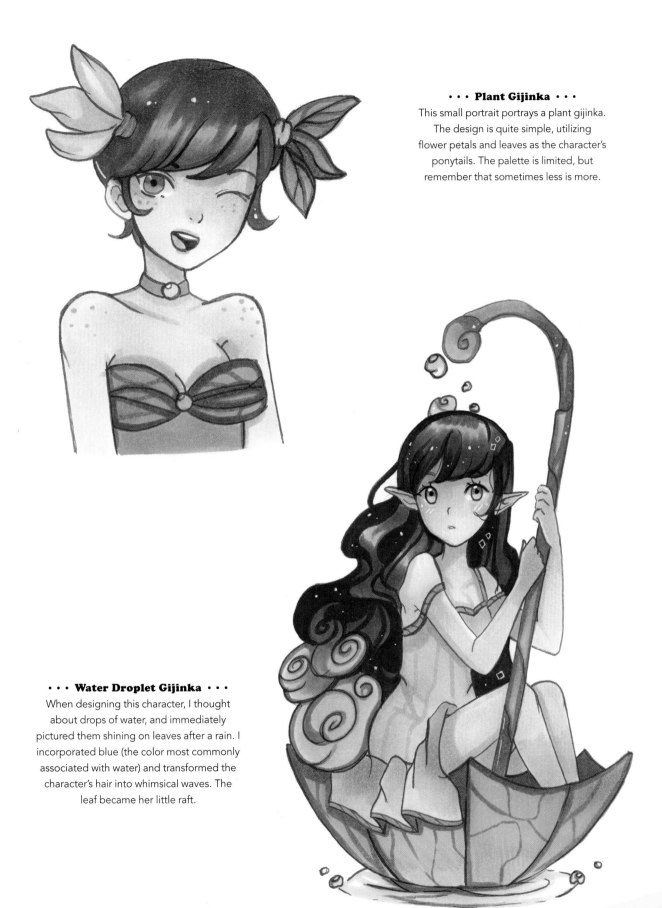

• • • Plant Gijinka • • •

This small portrait portrays a plant gijinka. The design is quite simple, utilizing flower petals and leaves as the character's ponytails. The palette is limited, but remember that sometimes less is more.

• • • Water Droplet Gijinka • • •

When designing this character, I thought about drops of water, and immediately pictured them shining on leaves after a rain. I incorporated blue (the color most commonly associated with water) and transformed the character's hair into whimsical waves. The leaf became her little raft.

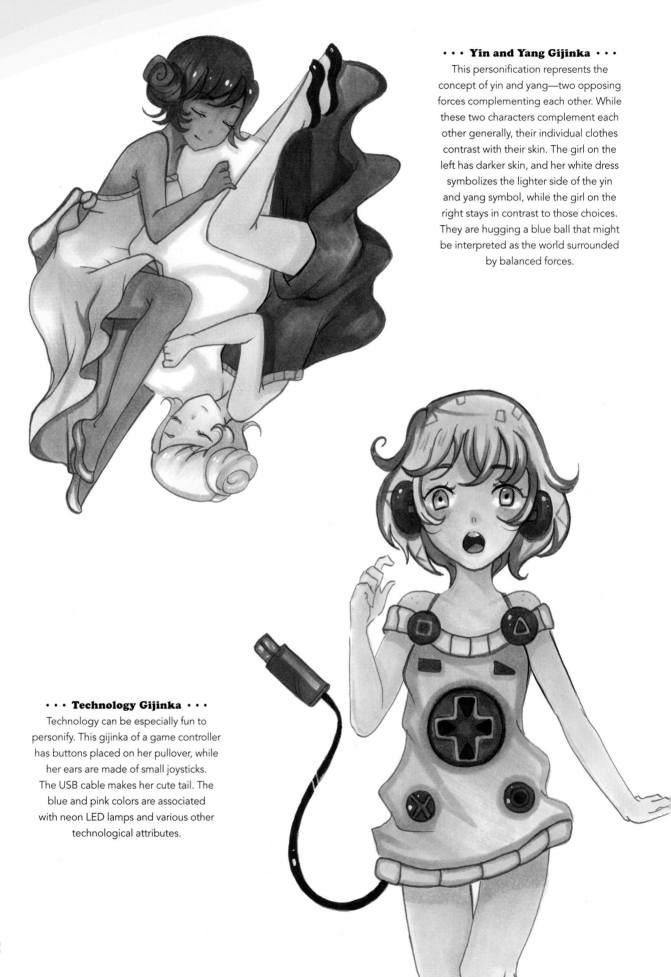

• • • Yin and Yang Gijinka • • •

This personification represents the concept of yin and yang—two opposing forces complementing each other. While these two characters complement each other generally, their individual clothes contrast with their skin. The girl on the left has darker skin, and her white dress symbolizes the lighter side of the yin and yang symbol, while the girl on the right stays in contrast to those choices. They are hugging a blue ball that might be interpreted as the world surrounded by balanced forces.

• • • Technology Gijinka • • •

Technology can be especially fun to personify. This gijinka of a game controller has buttons placed on her pullover, while her ears are made of small joysticks. The USB cable makes her cute tail. The blue and pink colors are associated with neon LED lamps and various other technological attributes.

USING SYMBOLISM

Using symbolism can add a deeper meaning to your illustrations. There are various ways to implement such elements into your artwork so that it will be more relatable and open to interpretation. This, in turn, will make it more interesting to viewers. The following examples will also show you how much depends on your color choices.

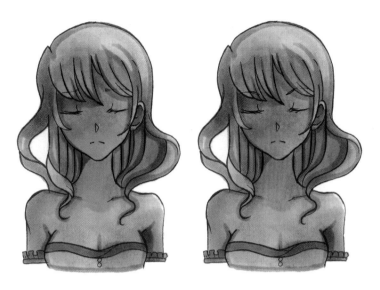

• • • Use Color to Hint at Mood • • •

In the left image, black and gray were used to emphasize the emotion of sadness that is expressed through the blue color. Blue is often associated with water, which can remind us of things like teardrops, rain or flood waters. This could symbolize a flood of emotions. For this reason, blue is a good color for melancholic pieces.

The image on the right features the same girl with red as the main color. Her eyebrows are also changed in a subtle way. Red is often associated with feelings such as love or anger. Is this girl angry or is she in love? Or could love be the source of her anger? Even the simplest images may leave a lot of room for interpretation.

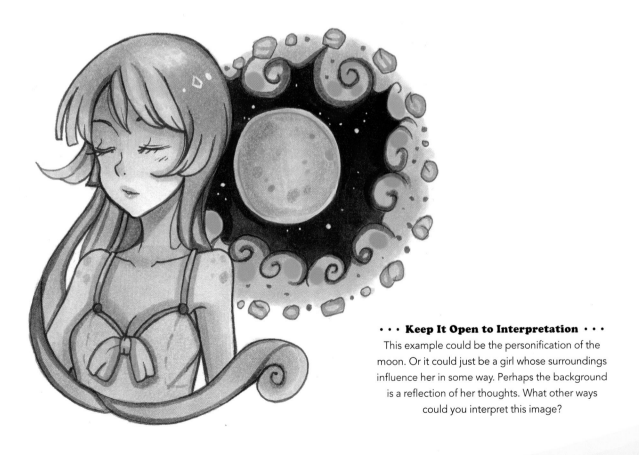

• • • Keep It Open to Interpretation • • •

This example could be the personification of the moon. Or it could just be a girl whose surroundings influence her in some way. Perhaps the background is a reflection of her thoughts. What other ways could you interpret this image?

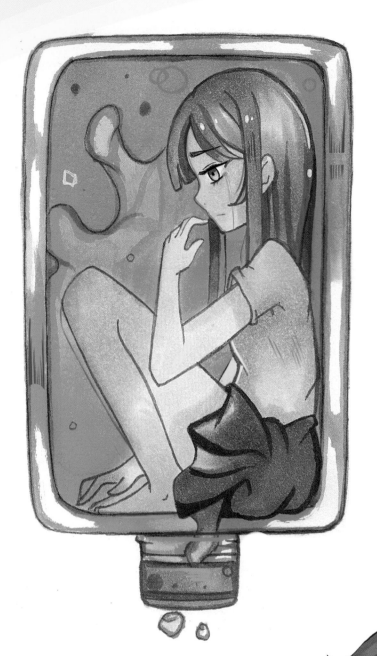

· · · Literal Versus Figurative · · ·

This portrayal of a girl sitting inside of a bottle doesn't have to be interpreted literally. Being bottled up could symbolize her emotional entrapment or the inability to break free from her own limitations. Remember that the more open to interpretation the image is, the bigger audience it will attract.

· · · Physical Traits Can Imply Emotions · · ·

This character's hair is all tangled, which could represent her messy thoughts or the sense of being lost in her own thoughts.

WORDLESS STORYTELLING

One of the main goals of an illustration is to tell a story, even if no words are present. Wordless storytelling can be a tremendous help when it comes to stirring creativity. Take a look at the short story below, which tells us about the life of a single seed. Because it lacks words, we are free to interpret it any way we choose.

Now try to come up with a story of your own that could be presented in a similar manner.

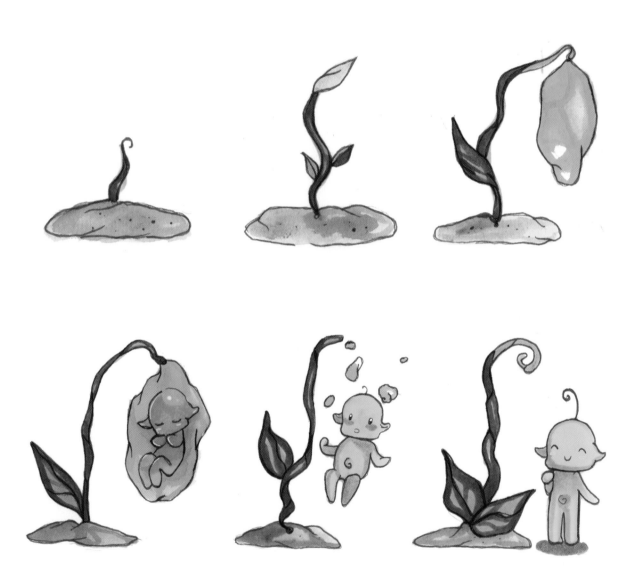

CREATIVE EXPRESSIONS

More often than not, the expression in a character's eyes can tell us more than words ever could. For this reason, the eyes are one of the most powerful means of relaying characters' emotions and telling their stories.

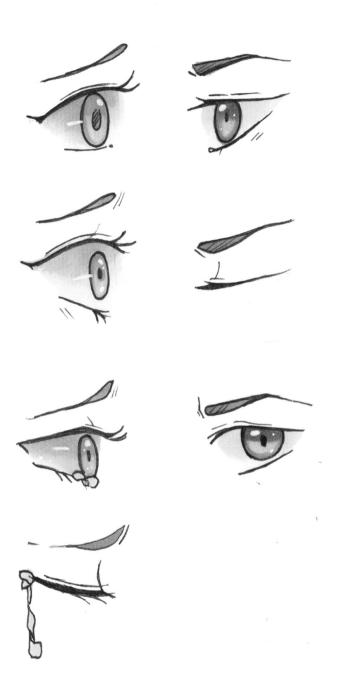

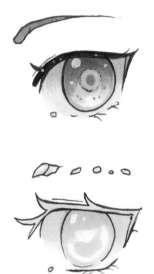

• • • Expressing Concepts • • •

Eye expressions can also be used to represent concepts. The eye on the top is a galactic eye, while the one on the bottom is a frozen eye. Notice how eyebrows can also be used to expand expressions. Try to think of more eyes like this and what they could represent. Fire? Autumn? The night sky? Anything is possible!

• • • An Eye Tale • • •

Take a look at this short eye tale. It shows someone departing and leaving somebody behind, and it portrays the exact moment of letting someone know they are about to be abandoned. The expressions in the characters' eyes alone are enough to convey the overall feeling of sadness and desperation.

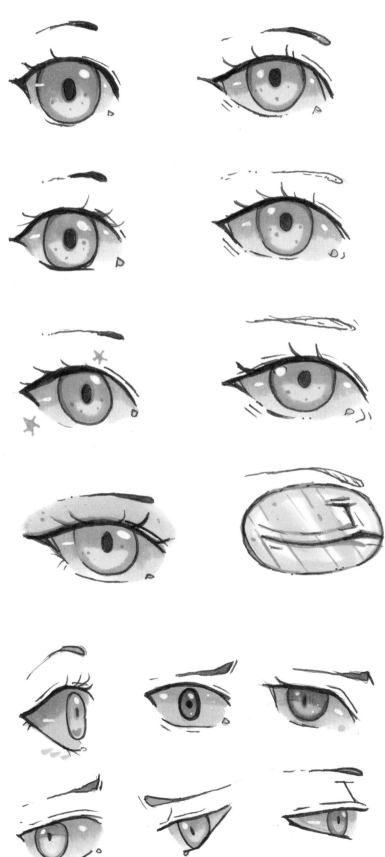

··· Aging Eyes ···

This eye tale shows the story of aging. By adding changes to such elements as the eyebrows, the makeup and the size of the eyes, we can show how the character has aged over time.

··· More Eye Tale Inspiration ···

Here are various eyes that could be used in creating your own eye stories. Think about the emotions they evoke in you and what kind of story you could tell by using them.

Key Words as Inspiration

Just as with concepts, certain words can also be used as inspiration for your character designs. Let's take a look at how a couple of key words have been used as a base for telling more eye tales.

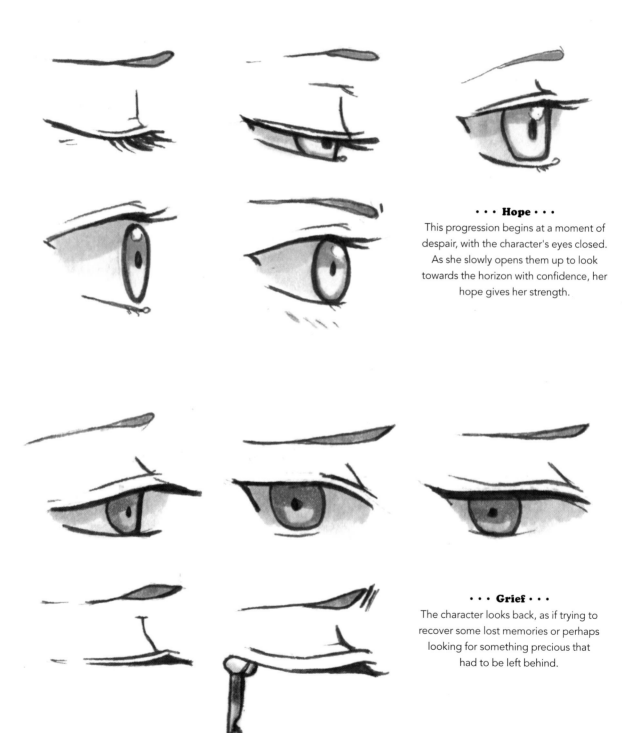

··· Hope ···

This progression begins at a moment of despair, with the character's eyes closed. As she slowly opens them up to look towards the horizon with confidence, her hope gives her strength.

··· Grief ···

The character looks back, as if trying to recover some lost memories or perhaps looking for something precious that had to be left behind.

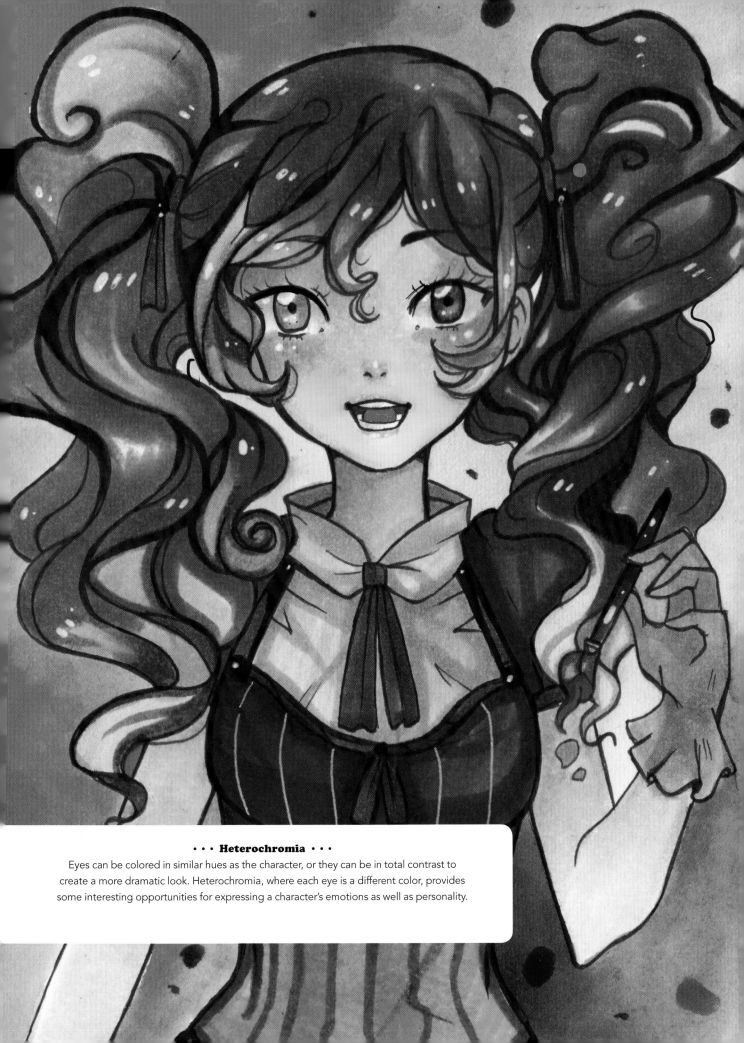

· · · Heterochromia · · ·

Eyes can be colored in similar hues as the character, or they can be in total contrast to create a more dramatic look. Heterochromia, where each eye is a different color, provides some interesting opportunities for expressing a character's emotions as well as personality.

CHAPTER

Putting It All Together

· FIVE ·

The previous chapters of this book walked you through the different components required to produce a creative illustration. Each of those elements and techniques plays an important role in delivering an impactful piece of art. Now let's take a look at how to incorporate all of those various elements together into a full scene.

DAY COMPOSITION

Follow the steps to compose and color your own unique day scene.

MATERIALS

Surface
watercolor paper

Sketching Tools
eraser
mechanical pencil
multiliner pen

Coloring Tools
markers
watercolor brushes
watercolor paints
white gel pen

1 Create a sketch of your composition with a pencil to give yourself an idea what you are going for. Outline the sketch with a multiliner.

2 Add a base layer of color to the skin with a light, skin-toned marker.

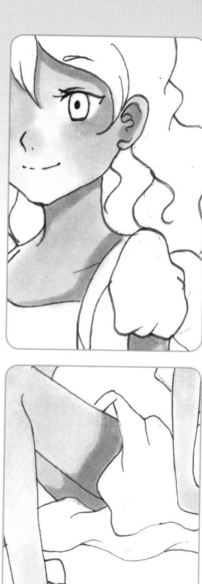

3 Apply heavy pressure to the shadow areas with a darker skin-toned marker. Most of the shadows will fall under the hair line, inside the ears, under the head and under the folds of the clothes. Darker shadows should also be added around the skirt and shoes.

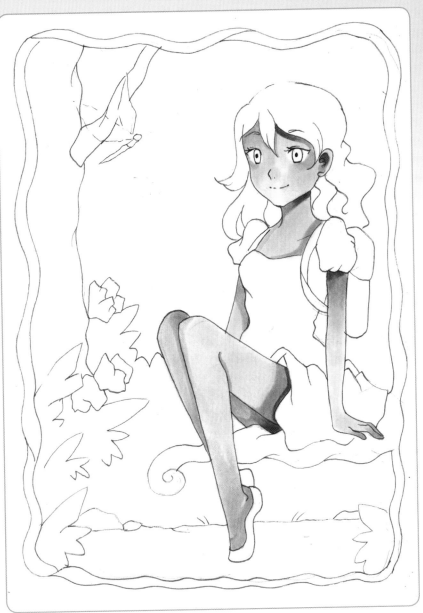

4 Add the darkest shadows with a dark purple marker. Then layer a light blue color onto her legs to reflect the nearby water. Notice once again where the darkest shadows should be added. Don't forget about the skirt area.

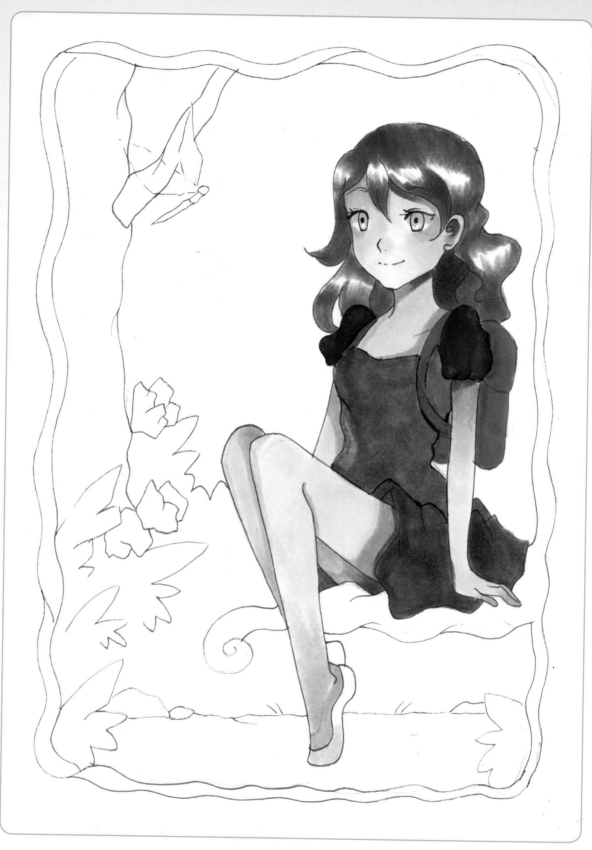

5 Add base colors to the clothes and hair. Be careful not to allow the marker to bleed across the multiliner outline. Add blue to the top of her shoe. Color her eyes a light green.

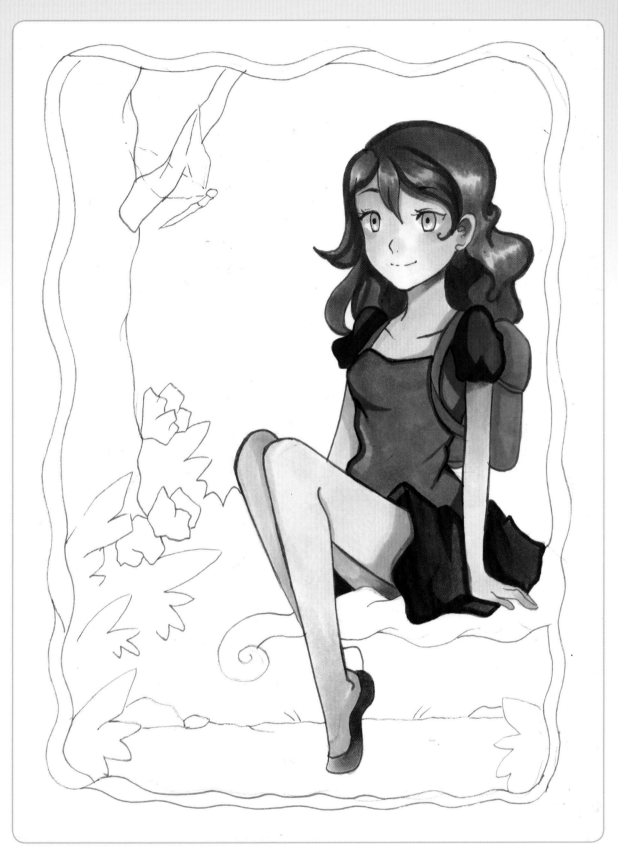

6 Add darker shades to the clothes and hair. Add highlights to the hair with a light green marker. This will tie into the forest setting.

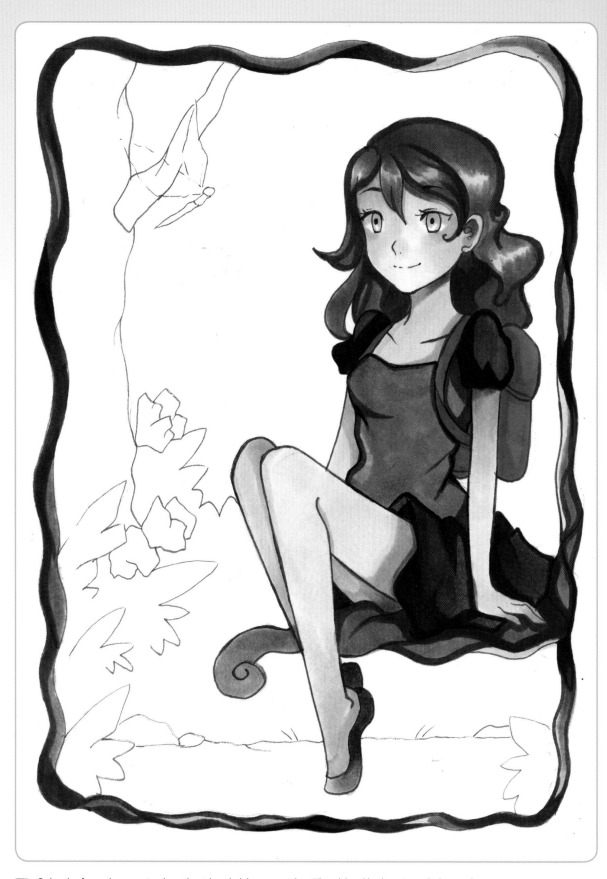

7 Color the frame by pressing heavily with a dark brown marker. Then blend by layering a lighter color over it. Add some blue highlights for contrast.

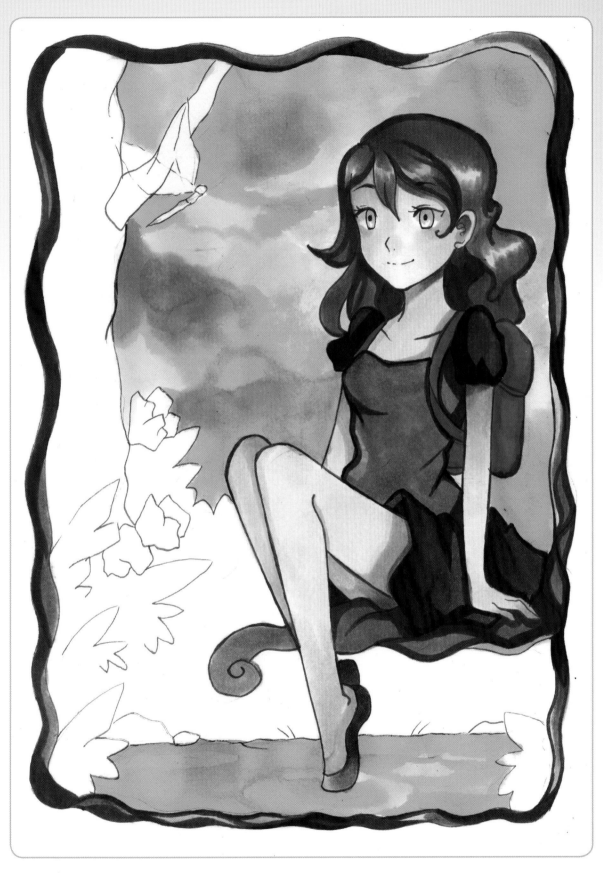

8 Add a layer of blue watercolor to the sky and the water.

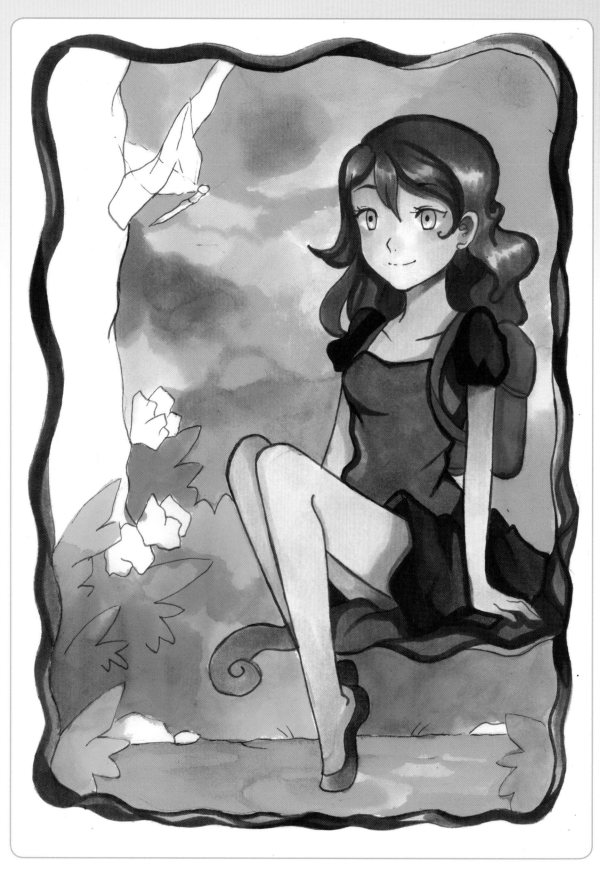

9 Add a layer of green watercolor to the bushes.

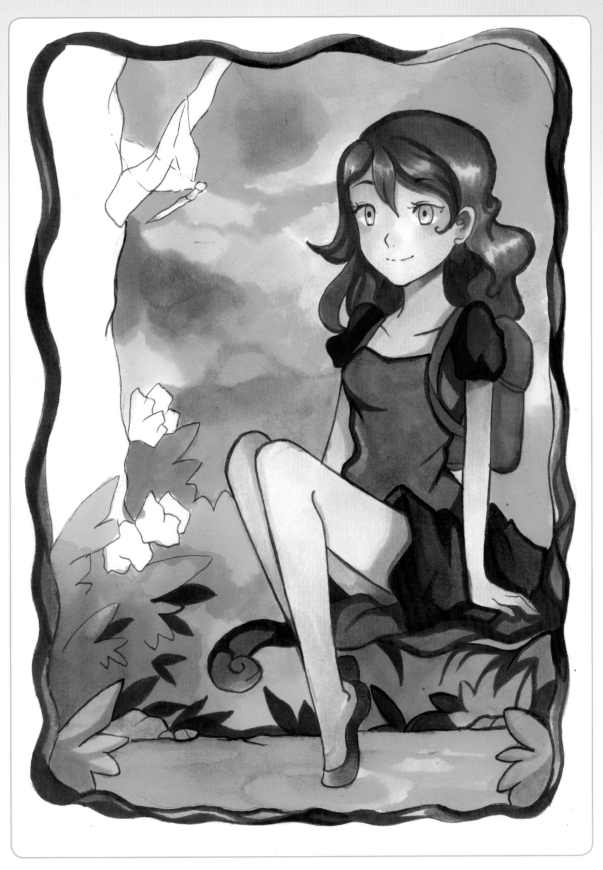

10 Use a dark green marker and heavy pressure to add the leaves.

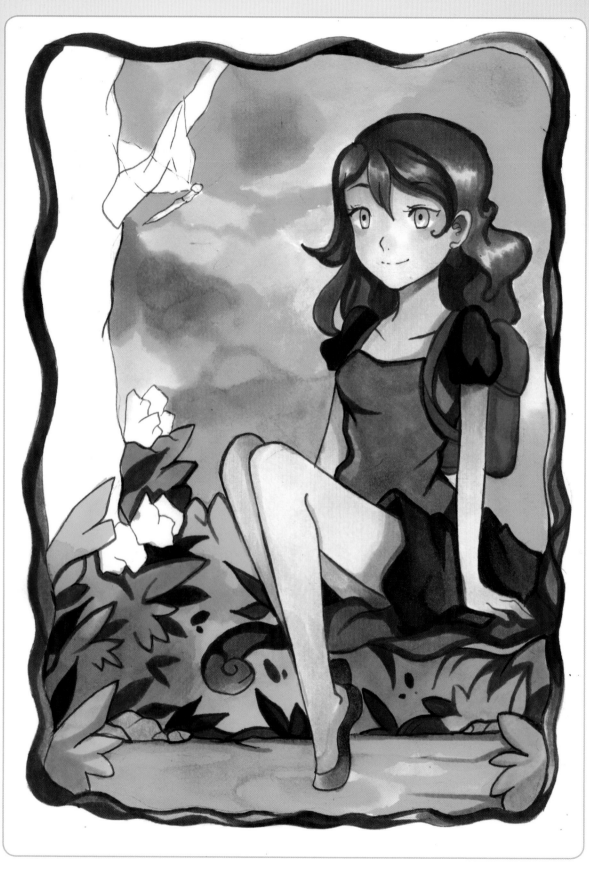

11 Continue developing the bushes. Add details to the water with a blue marker.

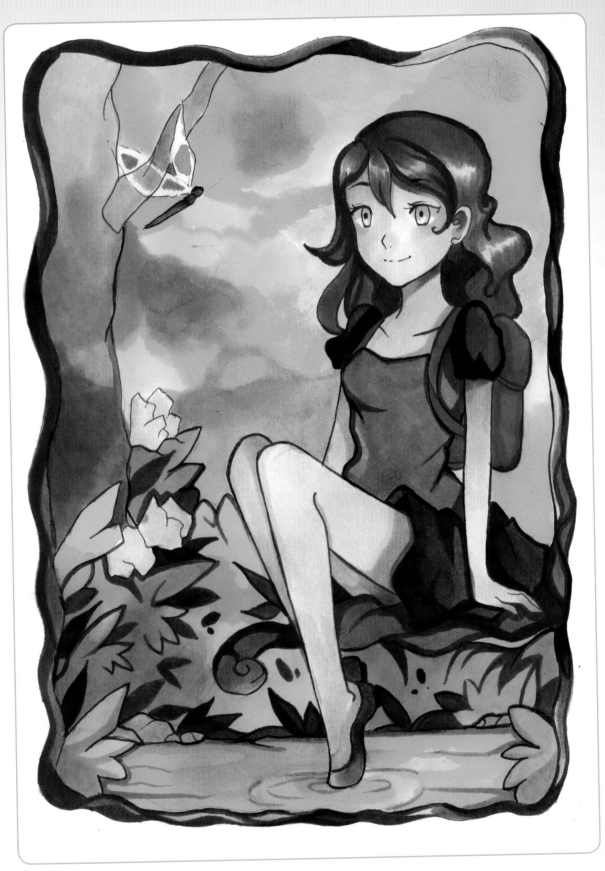

12 Color the tree with light brown watercolor. Use blue and green watercolor to begin coloring the dragonfly. Apply a base layer of pink watercolor to the flowers.

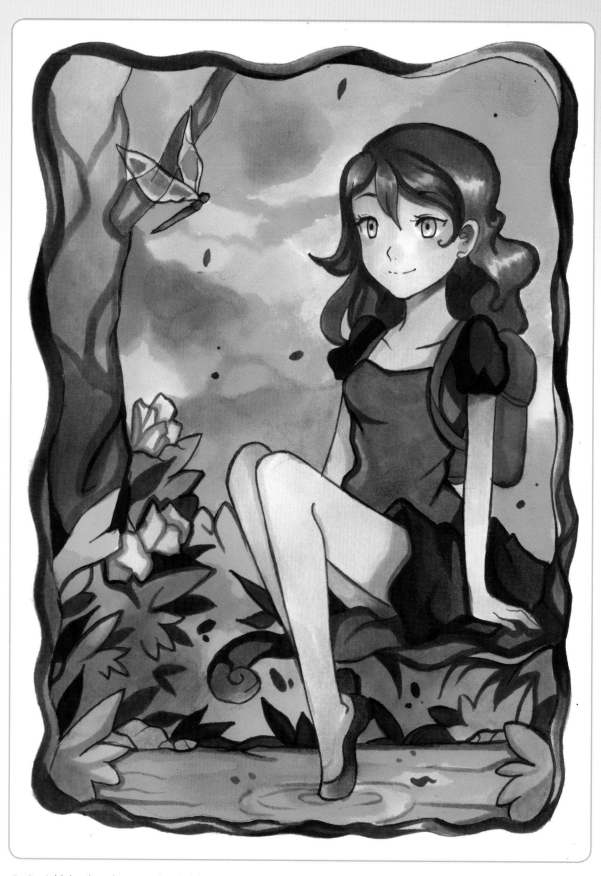

13 Add details to the tree with a dark brown marker. Continue to build up layers of color in the dragonfly and the flowers. Add some petals and pollen blowing in the background breeze.

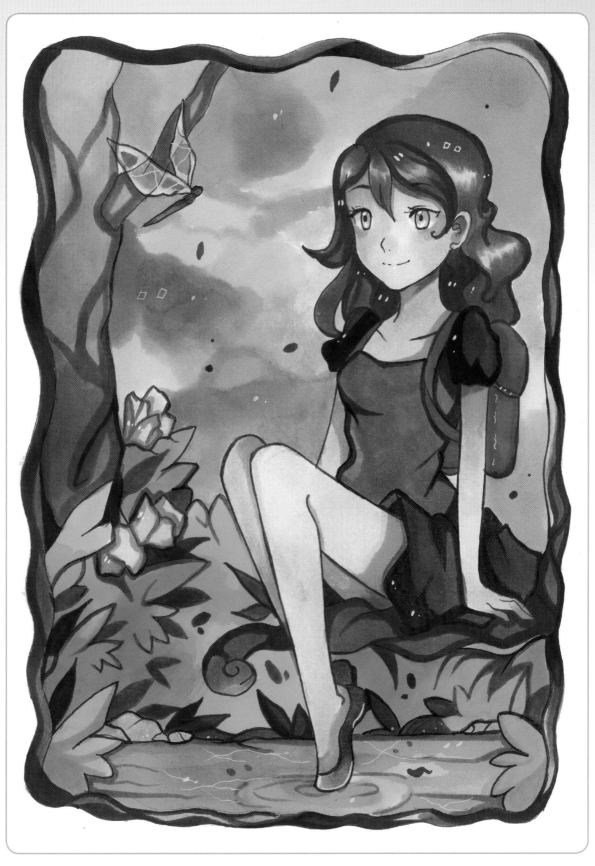

14 Use a white gel pen to add final details and highlights.

NIGHT COMPOSITION

Now follow along to learn how to compose and color a nighttime scene.

MATERIALS

Surface
watercolor paper

Sketching Tools
eraser
mechanical pencil
multiliner pen

Coloring Tools
markers
watercolor brushes
watercolor paints
white gel pen

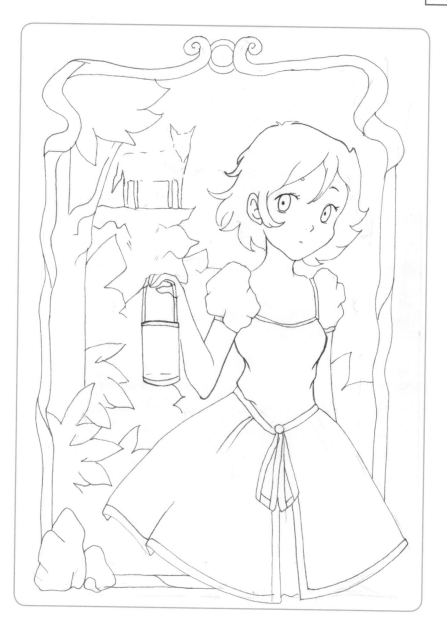

1 Create a sketch of your composition with a pencil, then outline it with a multiliner.

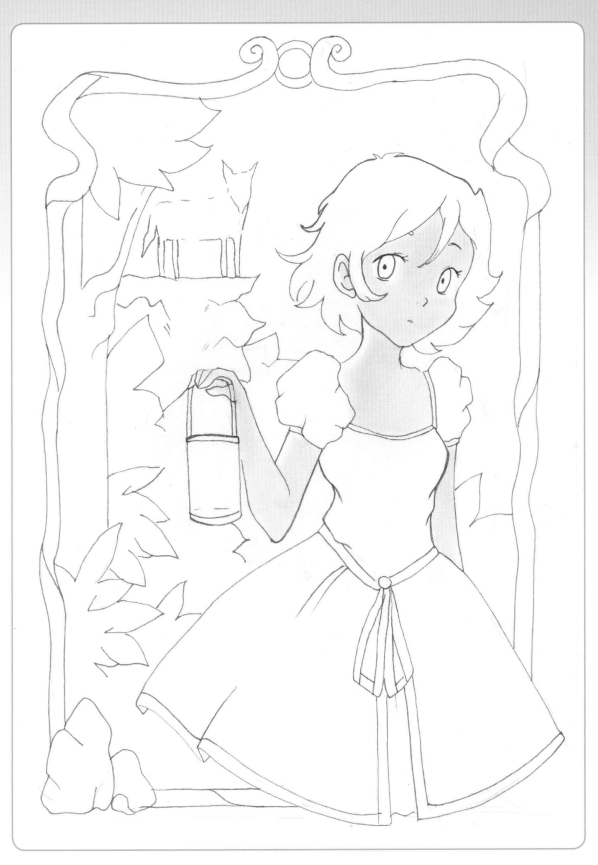

2 Add a base layer of color to the skin with a light, skin-toned marker.

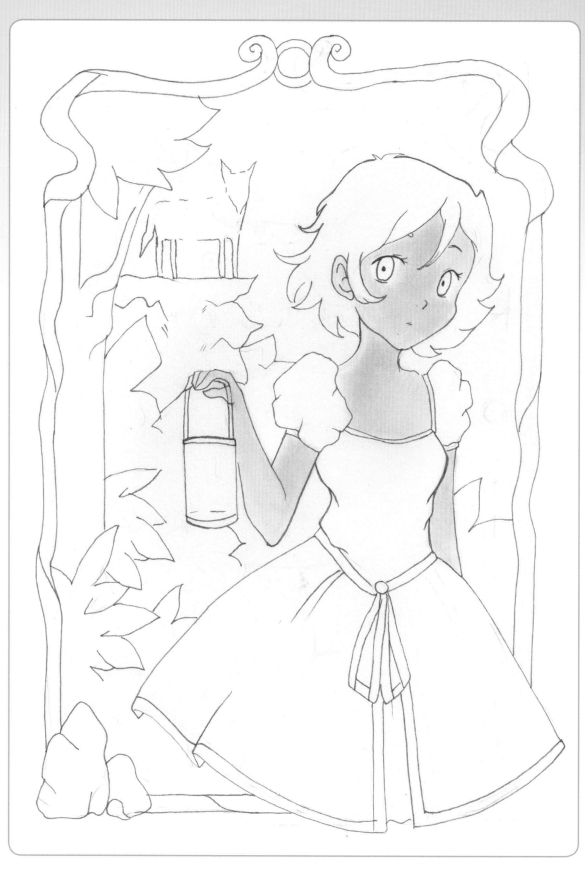

3 Color the left side of the character with a yellow marker. Then take a very light blue marker and apply another layer of color over the skin.

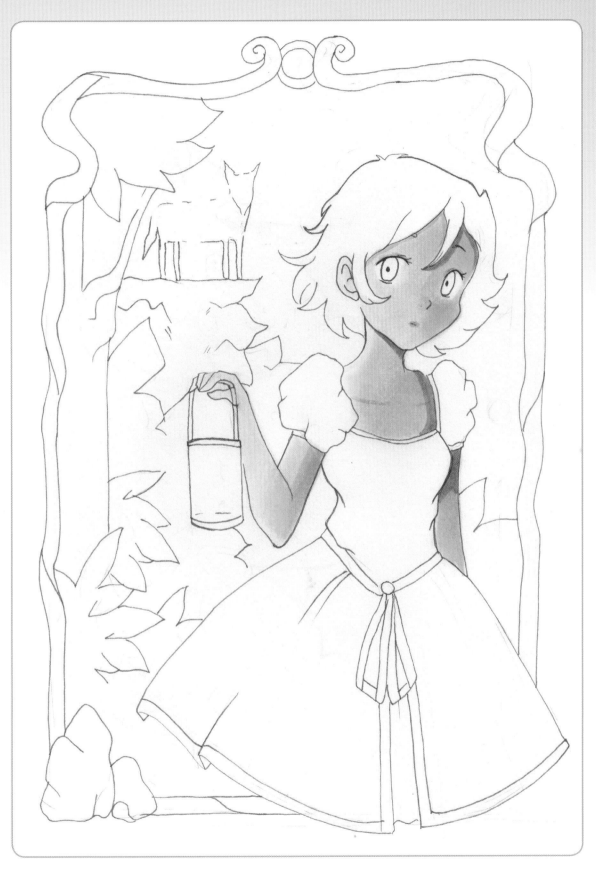

4 Press heavily with a darker shade of blue marker to add shadow to the right side of the character. These will be the darkest shades of the drawing.

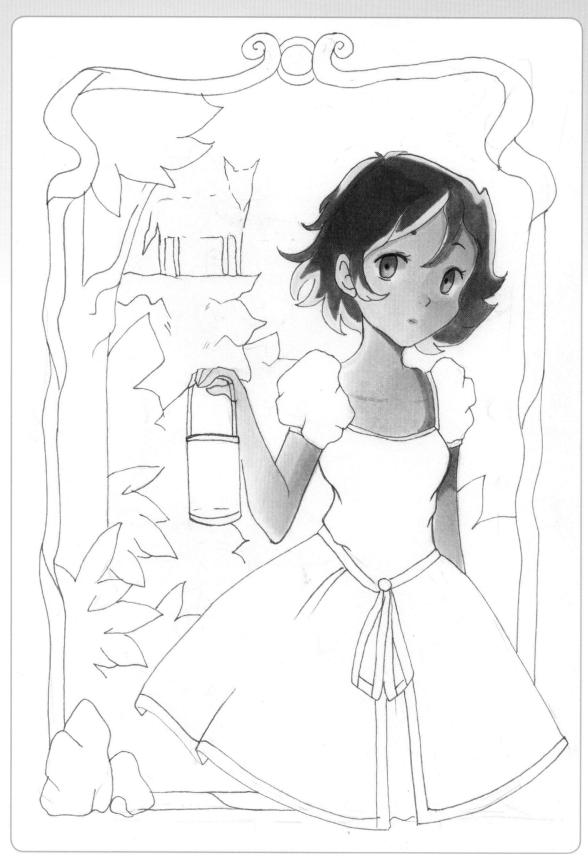

5 Use markers to color the eyes blue and add a base color to the hair. Leave some space towards the left edge of the hair outline and color it with yellow marker.

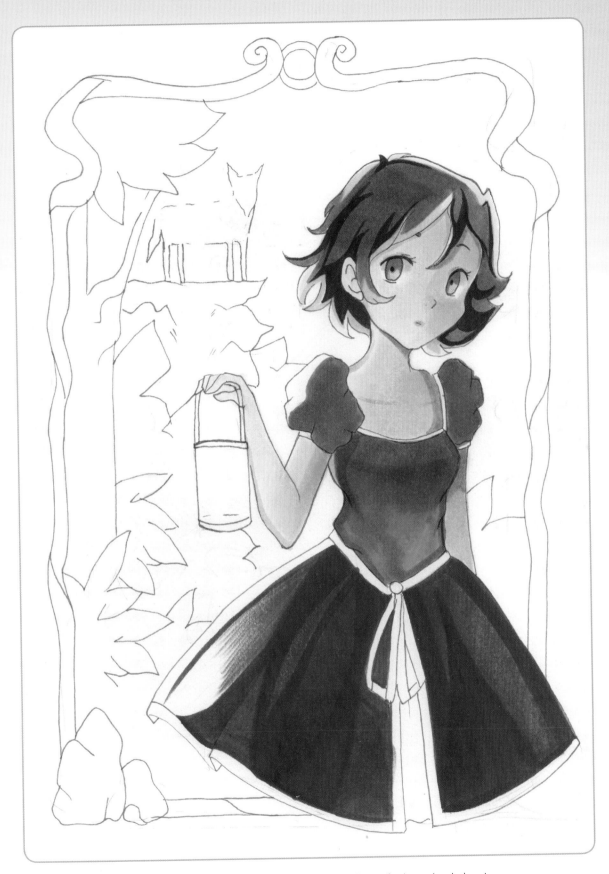

6 Continue using markers to add shadows to the hair and apply a base layer of color to the clothes. Leave some space to the left to add in more yellow.

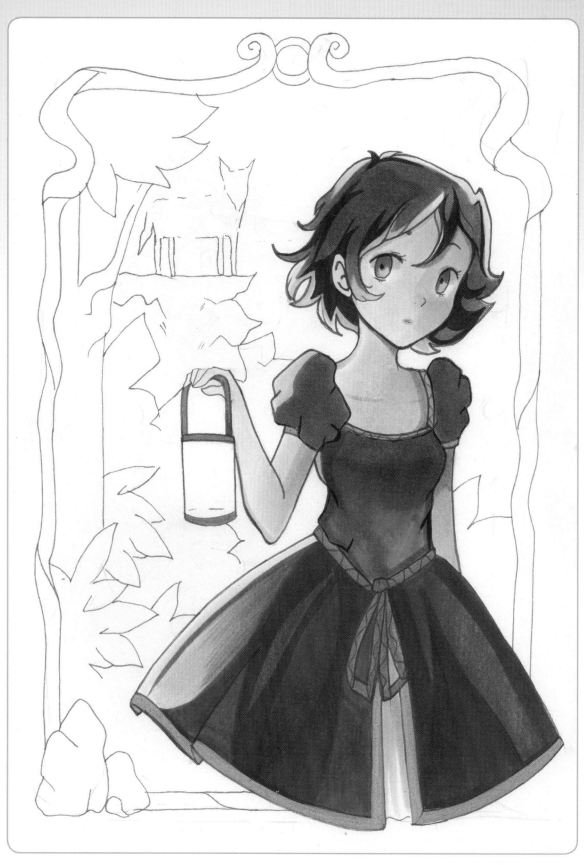

7 Continue adding details to the outfit and building up the areas of yellow light with marker. After you are done with this step, outline the character with a multiliner once again.

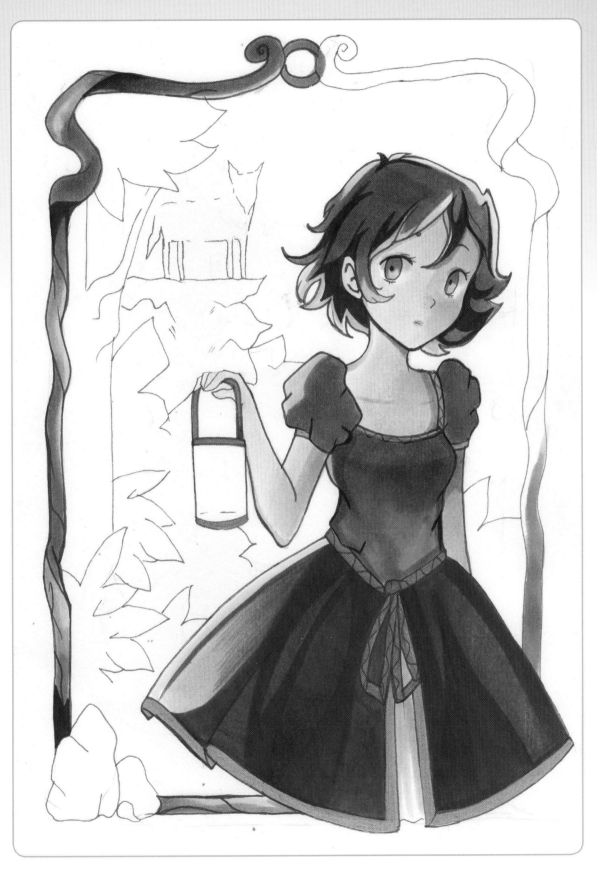

8 Now begin coloring the frame with brown marker. Add in some yellow highlights to blend everything together and keep the color scheme consistent.

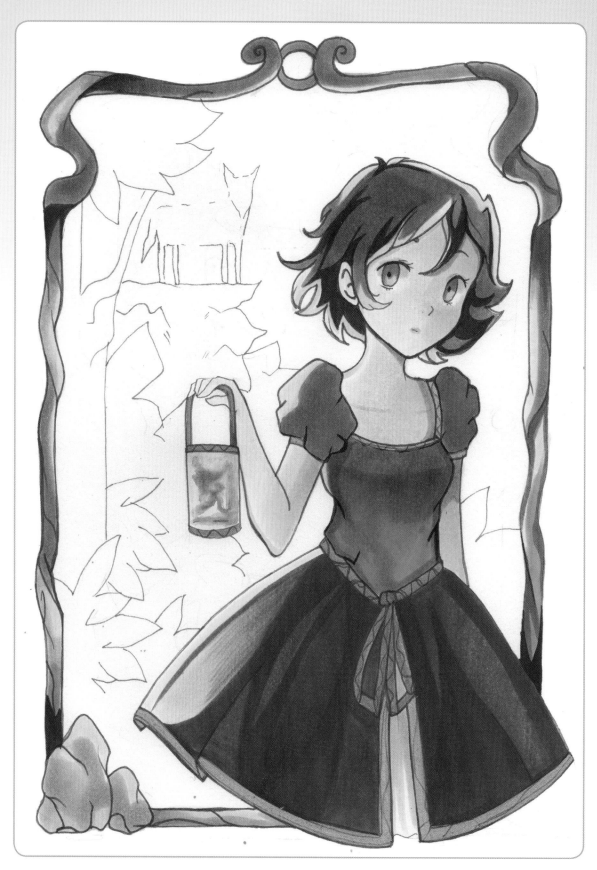

9 Add blue to the right side of the frame with marker, where the light would not reach. Color the lamp with watercolors by first applying yellow and then mixing in a little red while it is still wet. Apply gray watercolor to the rocks, adding a bit of yellow to the top.

10 Add a layer of blue watercolor to the background.

11 Color the background trees using strong pressure and a dark blue marker. Color the tree to the left with a base layer of light brown, then add shadows with a darker brown hue.

12 Color the wolf with a dark gray marker. Continue building up the background trees with a brown marker.

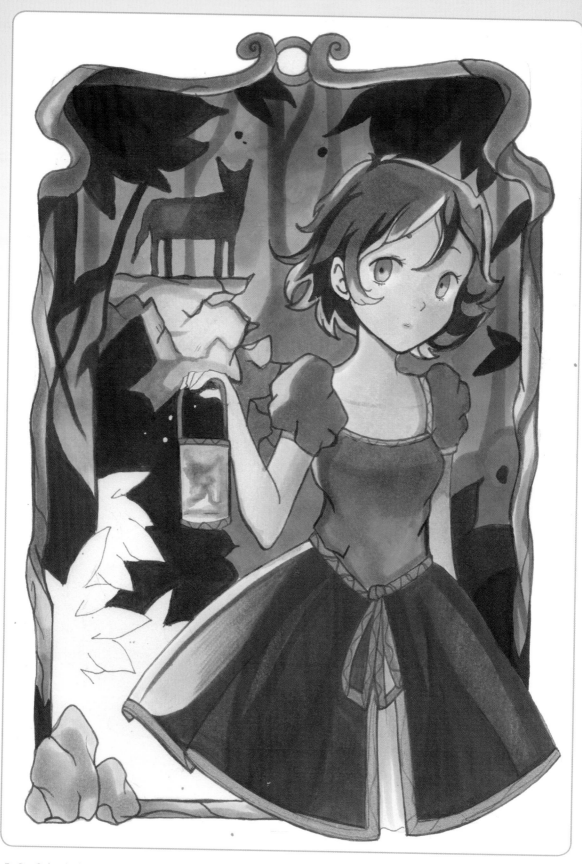

13 Color the bushes in the background with a base layer of dark blue marker.

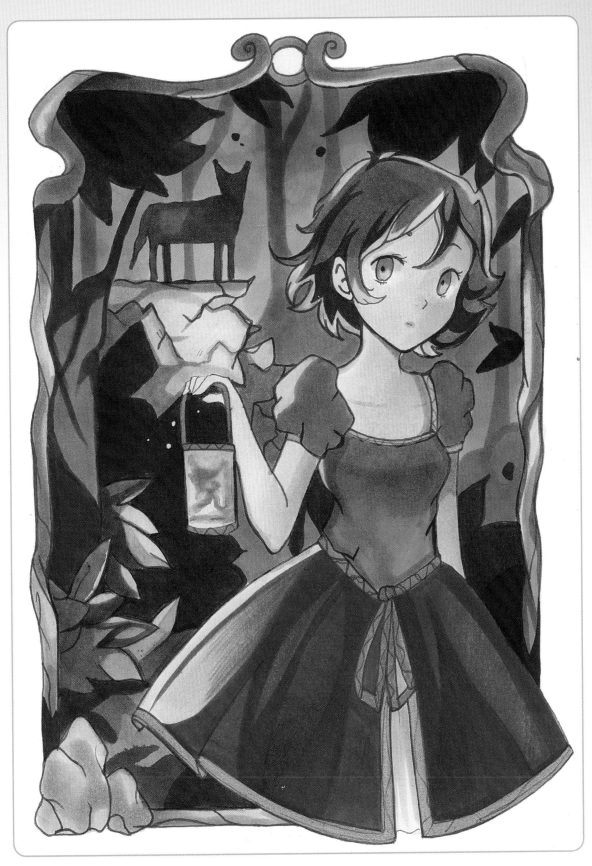

14 Layer dark green watercolor onto the bushes. Add light effects with yellow marker.

15 Use a white gel pen to add final details and highlights.

ADDING DETAILS & EFFECTS

Tiny details and added effects can make all the difference between a unified coherent illustration and a composition that feels unfinished.

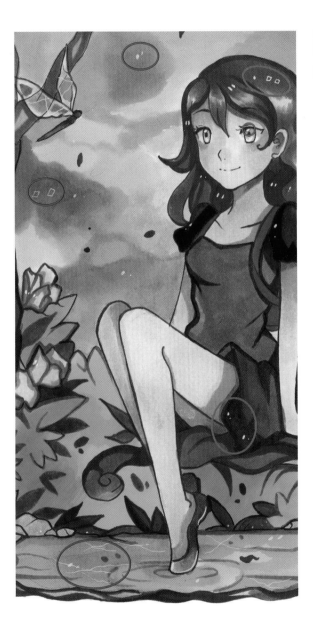

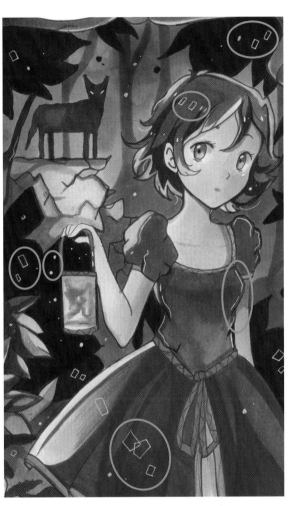

• • • Day Composition Detail and Effects • • •
Highlights in the background of the day composition represent everything from dandelion pollen to light effects from the sun. Adding highlights to the character's hair and eyes gave them more life. Water droplets were drawn onto the skirt, and details such as ripples were added to the water.

• • • Night Composition Details and Effects • • •
The night composition features added effects such as reflection in the eyes, hair highlights and light effects from the lamp. The lamp also has some white dots surrounding it that could be small insects drawn to the light. Finally, highlights and small details were added to the clothes to help them stand out against the darker colors in the composition.

121

Doily Pattern Effects

If you are having a hard time coming up with a pattern for your background or any other interesting effects, you can use a doily to add decorative elements to your art. Simply place a paper doily over your illustration, then color in the pattern holes with marker, pastel or airbrush.

Take a look at the examples below to see how a doily can be used to enhance a character's clothing or the background of a scene.

SCANNING

Have you ever tried scanning your illustrations only to have them come out looking terrible? You are not alone! This is a common problem for many traditional artists, because scanners tend to muddy up colors and make everything darker, resulting in an unattractive image. With proper editing, however, your results will be much different.

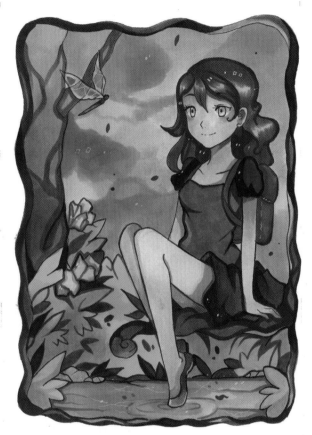

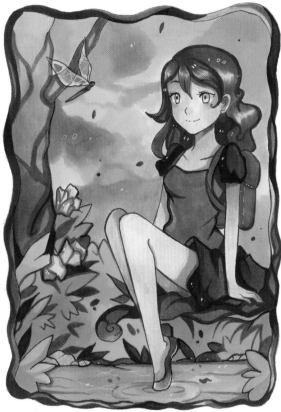

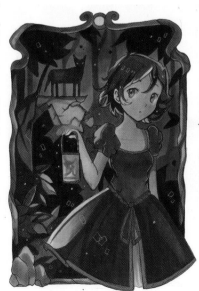

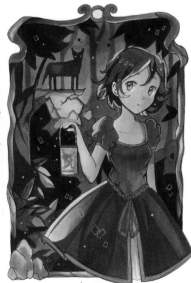

• • • Improve Scans • • •

Compare the illustrations on the left to the illustrations on the right. The examples on the left are way too dark, and the colors are not vibrant at all. What can be done to fix them? Use any good editing program, such as Adobe Photoshop, and play around with the Brightness and Contrast options. You will soon notice how much cleaner and more pleasing to the eye the composition looks.

Conclusion

The ability to conjure up creativity is one of the most important assets an artist can possess. I hope this book has helped you discover your own creative spirit and inspired you with many ideas as to how you can put it into action. Good luck and happy drawing!